CREATE:
NEW BEGINNINGS®

CREATE:
NEW BEGINNINGS®

AN ARTISTIC JOURNEY TO DEEPEN YOUR CONNECTION WITH GOD
AND EXPERIENCE HEALING AND HOPE

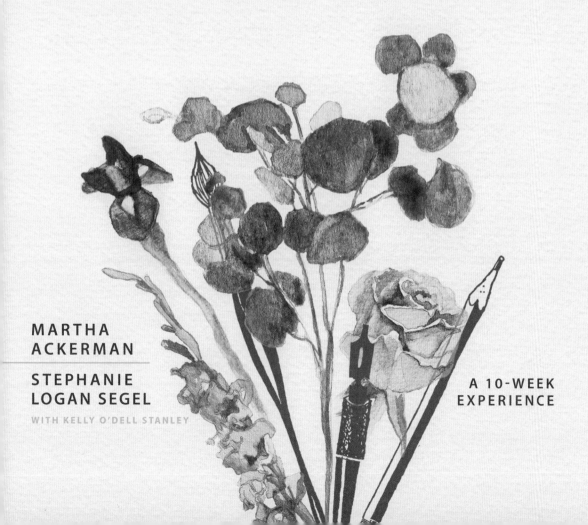

MARTHA
ACKERMAN

STEPHANIE
LOGAN SEGEL

WITH KELLY O'DELL STANLEY

A 10-WEEK
EXPERIENCE

Visit Tyndale online at tyndale.com.

Visit Tyndale Momentum online at tyndalemomentum.com.

Tyndale, Tyndale's quill logo, *Tyndale Momentum*, and the Tyndale Momentum logo are registered trademarks of Tyndale House Ministries. Tyndale Momentum is a nonfiction imprint of Tyndale House Publishers, Carol Stream, Illinois.

Create: New Beginnings is a registered trademark of Prison Fellowship. The Create: New Beginnings logo is a trademark of Prison Fellowship. All rights reserved.

Create: New Beginnings: An Artistic Journey to Deepen Your Connection with God and Experience Healing and Hope

Designed by Jennifer Phelps

Interior designed by Laura Cruise

For information about special discounts for bulk purchases, please contact Tyndale House Publishers at csresponse@tyndale.com, or call 1-855-277-9400.

Library of Congress Cataloging-in-Publication Data

A catalog record for this book is available from the Library of Congress.

ISBN 978-1-4964-6519-1

Printed in China

29 28 27 26 25 24 23
7 6 5 4 3 2 1

CONTENTS

HELLO, YOU!

Ready to create a new beginning?

There's just something about the idea of a fresh start that appeals to all of us on a deep level. A new beginning implies that there is hope. That change is possible.

But how do we get there? The answer is deceptively simple: We create.

Creativity is a tool anyone can use to tap into their past in order to change their future. This series of sessions was originally created to help people living in prison find healing through art by asking this question: What if art could turn pain into beauty? The creators of this program discovered that embracing creative opportunities led the participants to introspection, transformation, and a better understanding of how they see themselves and the world around them.

Whether we are in prison or not, many of us have similar questions about life. Who are we? How did we get here? How do we grow? How do we become better and stronger? How do we begin to heal from the pain in our lives?

Create: New Beginnings is a series of restorative art projects to help you on this journey for answers. Rooted in Scripture, this program offers a safe space for you to share your own journey and hear others' experiences.

Over the next ten weeks, we will be talking about and exploring through art the following themes:

1. *Vulnerability*, by identifying the difference between what we show people on the outside and how we actually feel on the inside
2. *Forgiveness*, with exercises to release bitterness and begin the journey to forgive

3. *Reconciliation*, thinking critically about a specific relationship that needs to be repaired
4. *Emotions*, identifying positive and negative ones
5. *Empathy*, sharing honest and compassionate appreciation for others
6. *Shame*, revisiting experiences that made you ashamed and determining the causes
7. *Self-doubt*, silencing inner voices that make you feel less than others
8. *Pride*, comparing healthy and unhealthy pride and pride versus humility
9. *Accountability*, taking responsibility for a time when your actions hurt someone
10. *Courage*, admitting to fears and how you handled them

You don't have to be "creative" to do this. You don't need any art background or experience at all—the goal is not to create a masterpiece. It is to simply join us in this safe space and trust the process. The art is an avenue for exploring your emotions and learning about yourself and your faith. We may look back at our lives from time to time, but our goal is to leave the past behind us. As we deepen our relationships with God through sharing and exploring, we will find a way to walk forward into a new beginning.

And did we mention that there is no homework? Our process of self-examination and creation is designed to be completed during our time together, so the only thing you need to do in order to prepare is to check out the materials list for each week and gather the necessary supplies. That being said, after experiencing something fun, energizing, or emotional, it's a letdown to just let it all go. So at the end of each session, we're going to give you one brief activity that you can carry with you into the rest of your week—if you feel like doing so—but nothing extra is required.

THE NITTY-GRITTY

Being creative is a balance between *the-sky's-the-limit-and-I-can-do-anything* and dealing with the practical details to make sure you have what you need to create. Before you get started, let's deal with the nitty-gritty.

The following lists contain recommended materials you need to complete the projects in this book. The first list is an all-purpose roundup of basic items. The second list is more detailed and geared to the individual sessions. Next to each item is a number, indicating the session for which it is used. You won't have to remember which items go with which session because there is a list at the beginning of each chapter reminding you what to bring. Be sure to check this list ahead of time in case you need time to find those materials. Your creativity doesn't have to be limited by the suggested materials on the following lists—feel free to substitute other materials you may have on hand if they will serve a similar purpose.

ART SUPPLIES

FOR EVERY SESSION

☐ MIXED-MEDIA ART PAPER Choose paper that is thick and textured enough to use with both acrylic and watercolor paint.

☐ PENCIL You don't need special art pencils; use whatever you have on hand for rough sketches and writing activities. No. 2 or 2B pencils tend to be the easiest to erase.

☐ PENCIL SHARPENER A small sharpener.

☐ ERASERS (Any type.)

☐ THICK BLACK PERMANENT MARKER Sharpie brand or similar waterproof marker that will write over dry acrylic paint.

☐ FOLDER to store loose paper and use as a drawing surface.

FOR SPECIFIC SESSIONS

☐ LARGE MIXED-MEDIA ART PAPER (size 11" x 14"): *Sessions 3, 6*

☐ COLORED PENCILS SET (any size): *Sessions 1, 3, 4, 5, 7*

☐ GLUE OR GLUE STICK This will be used for sticking paper on paper, so it does not need to be heavy duty: *Session 2*

☐ INDEX CARDS OR SMALL SHEETS OF LOOSE PAPER: *Sessions 2, 5*

☐ WATERCOLOR PAINT SET in a box or tray: *Sessions 4, 9, 10*

☐ ACRYLIC PAINT SET with black, white, red, yellow, blue, green, and brown: *Sessions 2, 6, 7, 8, 9*

☐ ACRYLIC PAINTBRUSHES IN A VARIETY OF SIZES Used for both acrylics and watercolors. You will need at least one small round brush (size 7 or 8) and one large flat brush (size 9–12): *Sessions 2, 4, 6, 7, 8, 9, 10*

☐ PALETTE PAPER OR REUSABLE PLASTIC PAINT PALETTE To hold and mix the acrylic paint: *Sessions 2, 6, 7, 8, 9*

☐ WATER CONTAINER Disposable cup or anything that will hold water for painting: *Sessions 2, 4, 6, 7, 8, 9, 10*

☐ PAPER TOWELS, A RAG, OR AN OLD T-SHIRT To wipe brushes and clean up any paint mess: *Sessions 2, 4, 6, 7, 8, 9, 10*

☐ FOLDER to use as a surface for tracing your profile: *Session 6*

OPTIONAL SUGGESTIONS

If you have some colorful WASHI TAPE, you may want to line the edges of the color charts in the Resources section at the back of the book for easy reference later. You may also want to add ADHESIVE TABS (or make your own) to help you find the first page of each session, and a RULER to use as needed.

WE'RE BETTER TOGETHER

While you may certainly explore these projects on your own, part of the value of the experience is sharing with and learning from others. If you are leading a group through *Create: New Beginnings*, we have tips and guidelines to help you. See the Facilitator's Guide on page 137.

THE CREATORS

Welcome! We—Martha, a jewelry designer, and Steph, a painter—are so happy you have chosen to participate in *Create: New Beginnings*! We want to tell you a little more about how this program came to be.

Our journey began in 2017 in an unexpected place: Rikers Island (Jail) in New York. In addition to sharing creative backgrounds, we share a common faith: We are both followers of Jesus Christ. We began working with incarcerated women through Prison Fellowship, the nation's largest Christian nonprofit serving prisoners and their families. (You can read more about this organization on pages 135–136.) At the time, Prison Fellowship was dramatically expanding its ministry to incarcerated women, helping to replace addiction and despair with futures of hope and purpose through events, resources, and intensive programs.

Through working with these women, we realized that art can be a valuable catalyst for open discussions—something women living in prison don't often have a chance to engage in. We saw the need for a resource to help incarcerated women tap into their past to change their future, so we were inspired to start a restorative art program grounded in biblical principles. *Create: New Beginnings* was born.

On this journey, we have learned that women in prison often feel isolated and alone. We immediately saw that *Create: New Beginnings* would provide the safe space necessary to discuss topics that are often taboo in prison culture, such as sources of shame and self-doubt. The program could also emphasize the importance of healthy relationships and create an environment for open, vulnerable community among prisoners.

We developed ten sessions to create a peaceful atmosphere through melodic worship, classical music, and interactive discussions while participants enjoy making art—something

rarely found in prison. As they create in community, participants feel safe to open up, realizing they are not alone. And all participants are reassured and challenged by the related Scriptures woven into the sessions.

We designed each art project to be engaging, accessible, and enjoyable—something any-one can do. We used our backgrounds in various art forms to create activities that people with little to no art skills can successfully complete.

From the beginning, we were encouraged by the participants, the volunteers, and the correctional facility staff about the value of this program. Since then, we have watched lives be transformed again and again through these restorative art sessions. We realized that this experience should be available to everyone, so we set about creating this book you are now holding in your hands.

There are countless different scenarios that might have led you here, and whatever they are, we are grateful you found your way to *Create: New Beginnings*. May we pray for you as you begin this journey?

Oh merciful God, we do not know all of the women who will find this program—but You do. You know their names, their circumstances, and exactly what each person needs. Please, Lord, shine Your light onto each and every life, gently illuminating the areas of transformation You have envisioned for them. We thank You for completely transform-ing us by this experience, and we pray that You will dramatically change their lives and hearts through the art they make alongside others. Amen.

God is *so* good!

With love,
MARTHA & STEPH

INSIDE/OUTSIDE MASKS
Vulnerability

ART SUPPLIES FOR SESSION 1

- ☐ 2 sheets of mixed-media art paper
- ☐ Black permanent marker
- ☐ Colored pencils
- ☐ Pencil sharpener
- ☐ Pencil

Stephanie Logan Segal

OKAY, THAT'S ALL FOR NOW

If you are here to get a jump start on this series, we love your enthusiasm . . . but that's the end of your prep for the first session. We've designed the program so that participants can work through the whole process while they are together as a group, so there's nothing else you need to do to prepare. There is no need to read ahead. All you'll need to do is grab your supplies and your book for the session that your facilitator designates and show up at the appropriate time!

WATCH A VIDEO from Martha and Stephanie about this week's session at tyndale.life/create_session1.

LOOKING AHEAD

Is it difficult for you to be vulnerable? In this session, we're going to draw self-portrait masks as we discuss what it means to be vulnerable. By sharing insecurities, we may uncover hidden feelings and truths. The masks will help us express the difference between what we show people on the outside and how we truly feel on the inside.

EXAMINE

LOOKING INSIDE

> The real legacy of my life was my biggest failure—that I was an ex-convict. My greatest humiliation—being sent to prison—was the beginning of God's greatest use of my life; He chose the one thing in which I could not glory for His glory.
> —CHUCK COLSON, FOUNDER OF PRISON FELLOWSHIP

Probably every single one of us, at one time or another, has hidden our true feelings or failures from others. Before we dive into the topic of vulnerability, we'd like to set the stage with Scripture and a prayer. The apostle Paul writes,

> Three different times I begged the Lord to take [my thorn in the flesh] away. Each time he said, "My grace is all you need. My power works best in weakness." So now I am glad to boast about my weaknesses, so that the power of Christ can work through me. —2 CORINTHIANS 12:8-9, NLT

Scripture doesn't elaborate what Paul's "thorn in the flesh" actually was, but his repeated requests suggest he suffered from some chronic, debilitating physical problem. Whatever we are facing, it can be scary to admit weaknesses or mistakes that might open us up to criticism or rejection, but when we do this with God, we don't have to worry. He offers us refuge and welcomes us with open arms. When we allow ourselves to be vulnerable with other trustworthy people, it can be an important part of the healing process. Sharing openly—when done in an honest, loving, nonjudgmental way—can bring us into a more loving and trusted relationship with others.

Lord God, I know I never have to hide anything from You. Please help me to have the courage and wisdom to be open with people in an honest and loving way, bringing healing and comfort to myself and others. In Jesus' name, amen.

PERSONAL REFLECTIONS

PRESENTATION OF FLOWERS

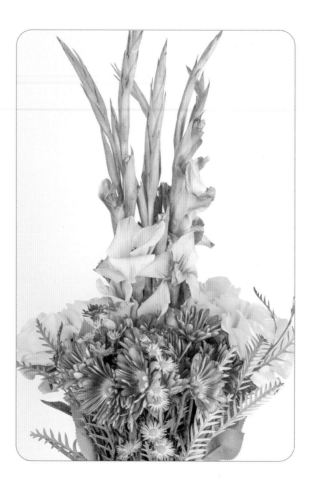

Who doesn't love flowers? Their colors, shapes, and scents brighten any space. In Victorian times, when someone gave flowers to another person, they often chose varieties that had a specific and sometimes silent message. This ability to represent feelings and convey messages became known as the "language of flowers." Throughout these sessions, we will use this same language to bring meaningful messages to enrich our time together.

First, we have a GLADIOLUS, a tall and regal flower that represents strength of character, generosity, integrity, and faithfulness—and its firm, upstanding appearance says to never give up.

We also have the CHRYSANTHEMUM, which represents optimism, honesty, joy, rest, and long life.

The last flower is the YELLOW ROSE, which symbolizes friendship, joy, and caring.

As you look at the flowers, we hope you will absorb our message for you today. We wish you a life filled with faithfulness, integrity, generosity, and strong character. We hope those traits will help you grow healthy, trusting friendships in which you can be vulnerable, and we pray that your life will be infused with honesty, joy, and optimism. In every step of your journey, may you have the determination to never give up.

Love,
MARTHA & STEPH

SHARING OUR EXPERIENCES

> Faithful are the wounds of a friend.
> —PROVERBS 27:6, ESV

We like to think that friends would never hurt us, but this verse tells us that even the best of friends with the best of intentions can say things that hurt. They might tell us things we need to hear—out of love—even if it is painful. If you are too afraid to say what needs to be said to your friend, or if a friend is too afraid to say what needs to be said to you, is that a true friendship?

Dr. Brené Brown is a well-known research professor on topics like shame, courage, and vulnerability. In her book *Daring Greatly*, she writes:

> Vulnerability is the birthplace of love, belonging, joy, courage, empathy, and creativity. It is the source of hope, empathy, accountability, and authenticity.

Think about this next question: When might you wear a mask and why?

People often do not realize that they put on a front, or a mask, when interacting with others. Let's think about what it means to put on a mask and why we sometimes do that. We wear masks for protection, so we don't have to be vulnerable. Sometimes we want to hide our emotions when we're going through a difficult time or when we're not sure what we're supposed to do. We may put on an outside mask to seem calm and peaceful as we love our children when actually, on the inside, we're stressed and overwhelmed. We might wear a mask at work to seem professional when we are actually in pain or hide behind a mask to keep strangers from seeing too much of our true feelings. There are many masks we wear for many reasons, sometimes all within the same day.

WARMING UP

Before we begin our art project today, we're going to get our imagination flowing with a fun and creative writing activity.

Imagine you're writing a book about yourself. We're going to write an *intro scene*, or in other words, the opening setting of a story or book. We'll call it *The Real Me*, and that's exactly what it's about—the real you, the person you might not always let people see.

For the next few minutes, use your imagination and simply write a few sentences to begin your story. How would the story of the real you begin? It's totally up to you, but you may choose to re-create a scene from your memories that you feel would help others understand you (or you may discover that it will actually help you understand more about yourself). Or maybe your opening scene describes a place or a setting that you feel reflects who you are at your core. Perhaps it's a moment in which you felt fully alive, fully loved, fully accepted.

Whatever it is, know that what you create right now is not supposed to be perfect or final. Don't worry if it doesn't even make much sense. Just keep your pencil moving. We'll stop the music when the time is up. You will have about five minutes to write your scene.

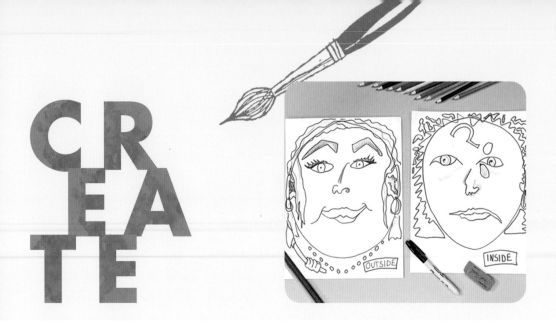

CREATE

We have discussed when and why we might wear a mask. Now let's consider how we might look when we are hiding behind a mask rather than letting people see the real us. For our art project today, we are going to reveal our true selves by creating masks, using paper, a marker, and colored pencils.

Use your black marker to draw an oval shape on one sheet of your mixed-media paper, filling the whole sheet. Add eyes, nose, and a mouth inside the oval. Write the word *Outside* at the bottom of your paper. This drawing represents the version of yourself that you show other people.

On that same paper, use colored pencils to fill in your mask drawing. You might include your facial features, piercings, or jewelry. You could incorporate depictions of things you love—God, your children, a hobby, or something you would share or show to most people. Maybe you depict a smiling happy face even if that's not how you feel inside. Maybe you show a tough face when you feel broken or vulnerable. Work on this for about ten minutes.

Now set aside your Outside mask, and let's move on to your Inside mask.

Using your second piece of mixed-media paper, draw the oval, eyes, nose, and mouth in the same way you began the first mask. At the bottom of the paper write *Inside* to identify that this drawing represents what is really going on inside you. As you do this, think about how you would look if you didn't wear any mask, if people could see past the surface into your mind and heart. In other words, draw a mask that represents your most vulnerable self—all the emotions, thoughts, traits, or desires that you usually hide under your Outside mask. Once again, you will have ten minutes to complete this, and we will stop the music when the time is up.

It is an act of vulnerability to share personal artwork. We really value and appreciate your willingness to share! Who wants to share their Outside and Inside masks?

It's important to be reminded that oftentimes, the way we see ourselves and how God actually sees us may be two completely different things. So, now that we have examined how we see ourselves, let's talk about this question:

How does God see us? (*Example:* We are loved.)

We read in Psalm 139,

> If I say, "Surely the darkness will hide me, and the light become night around me," even the darkness will not be dark to you; the night will shine like the day, for darkness is as light to you. For you created my inmost being; you knit me together in my mother's womb. I praise you because I am fearfully and wonderfully made.
> —PSALM 139:11-14

God loves you and sees past the masks you wear. Some of us might find that discouraging because we think of all the ways we may fall short in God's eyes. But know this: He sees your worth behind the mask, even when it's difficult for you to see it yourself. When we ask God in prayer to help us change, He will start to transform us from the inside out, working gently toward the day when our inside and outside masks are exact matches.

As we learned through all of you who openly shared your stories and art, vulnerability is about being honest and open with a trusted person. When we do that in a safe space, such as the one we have here, we give and receive comfort as well as build relationships with one another. Similarly, but even more profoundly, when we allow ourselves to be vulnerable with God through prayer and reading His Word, we get to know Him better and find comfort and acceptance in the safest of safe places.

As you leave today, think of a specific relationship in which you might apply what you learned in this session about being vulnerable. But before you go, let's discuss who will provide the flowers for each week's session. (Facilitators, please see the note in the Facilitator's Guide under Presentation of Flowers.)

NOW LET'S CLOSE OUR TIME TOGETHER IN PRAYER.

Lord God, when You came to us as a vulnerable human being, You showed us what it is to be real and authentic and touchable. Your life was the perfect example that teaches us how to be faithful and constant. Show us how to demonstrate those same qualities and to be a friend to others as You have been to us. Give us wisdom to choose safe people with whom we can be vulnerable and bring us a faithful friend who can be a mirror to us in a healthy way. In Jesus' name, amen.

PERSONAL REFLECTION

REFLECT AND REMEMBER

Here's what past participants have said about their experiences. Read through their words, and then add your own brief reflections to help you remember what the session was all about.

WHAT PEOPLE SAID THEY LIKED BEST ABOUT SESSION 1

VULNERABILITY

- "Seeing the reality of how different I let others see me and how I see myself."
- "It will be able to heal the inside of me."
- "I liked how we could be ourselves and the honesty everyone shared."
- "Seeing the two faces that were made. . . . When you see someone you live with, you assume you know their inner selves/feelings."

WHAT I SAY

REINFORCE

At the end of each session, you will find a bonus exercise which is created for you to do on your own sometime during the coming week, in order to help you continue to live what you just learned. These exercises are completely optional; they are designed to help you retain what you just experienced. Don't feel any pressure to complete this section unless it is fun for you. If it seems like work, feel free to skip it without any guilt whatsoever.

Wearing a mask used to be more of an abstract concept—one reserved for a day like Halloween—but since the first time we heard the word *coronavirus*, it's become something we have more direct experience with. Many people discovered that covering a part of their face freed them from some social expectations, such as making eye contact and smiling. What has your experience with wearing masks taught you about yourself?

If you have a spare cloth or disposable mask, use markers or paint to decorate it—maybe you'd like to draw the smile that the mask hides from view. Or perhaps you'd like to write a message on it to encourage others, such as "Hang in there" or "We're all in this together" or "You are seen." As you create, offer heartfelt thanks to God for being able to see past the surface to what He has planted in your heart.

STRESS PAINTING
Forgiveness

ART SUPPLIES FOR SESSION 2

- ☐ Index card or loose sheet of paper
- ☐ 1 sheet of mixed-media art paper
- ☐ Palette paper or reusable plastic paint palette
- ☐ Set of acrylic paints
- ☐ Large acrylic paintbrush
- ☐ Glue or glue stick
- ☐ Disposable cup or water container
- ☐ Paper towels or rag to wipe brushes and clean up paint mess
- ☐ Pencil

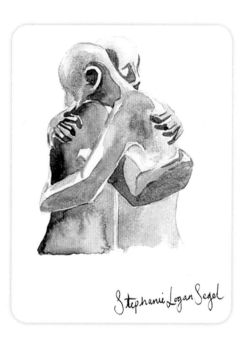

Stephanie Logan Segal

Prep just before the beginning of the session

Create a circle with dabs of paint on the waxy side of the palette paper or on the plastic paint palette. Use no more than dime-sized amounts of each color of paint, spaced approximately 1½ inches apart. If you are using palette paper, you may fold the paper in half to conserve space and create a sturdier palette. Set this aside until it's time to paint your project. Also fill your cup or water container.

WATCH A VIDEO from Martha and Stephanie about this week's session at tyndale.life/create_session2.

LOOKING AHEAD

In this session, we are going to explore the topic of forgiveness through writing, art, and discussion. Forgiveness—like all of our topics—is a sensitive one. Please remember to keep what you hear confidential and do not repeat it, just as others will honor you in the same way. Everyone needs to feel comfortable and free to share and to be vulnerable.

EXAMINE

LOOKING INSIDE

> Forgiveness is the key that unlocks the door of resentment and the handcuffs of hatred. It is a power that breaks the chains of bitterness and the shackles of selfishness. —CORRIE TEN BOOM, HOLOCAUST SURVIVOR

There is so much power in forgiveness. But it's not that easy, is it? Before we discuss this, let's see what the Bible says about forgiveness:

> Do not judge, and you will not be judged. Do not condemn, and you will not be condemned. Forgive, and you will be forgiven. —LUKE 6:37

When we think about all that Corrie ten Boom must have endured—and yet really think about the words she said—we can begin to understand just how powerful forgiveness is. Does that overwhelm you? Try not to let it. The truth is that God has asked us to forgive, and He will help give us a genuine heart to enable us to accomplish what might be impossible without Him.

LET'S PRAY TOGETHER.

Lord God, I know I never have to hide anything from You. Please help me to have the wisdom to forgive those who have hurt me and the courage to receive forgiveness from those I have hurt. Please help me do this in an honest and loving way that brings healing and comfort to myself and others. In Jesus' name, amen.

PRESENTATION OF FLOWERS

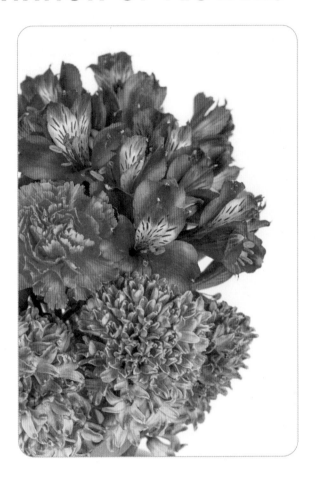

As you learned in the first session, people in Victorian times used flowers to convey silent messages and feelings. We love that concept, so we will continue to incorporate the meanings of specific flowers that relate to our discussion topic in each session.

Today we feature the PURPLE HYACINTH, which represents forgiveness and new beginnings.

We also have the CARNATION, which means "I will never forget you."

Our wish for you, spoken through today's flowers, is that you will find the strength to recognize those areas where you need to either forgive or be forgiven so that you can find a new beginning. We hope you enjoy the love and devotion of family and friends and that as you move forward toward achieving your dreams, you will be supported by others who share like-minded healthy goals and encourage you along the way. We wish all these things for you because we believe—and hope you will too—that God can soften your heart in order to allow you to be open to change.

Love,
MARTHA & STEPH

Finally, there is the ALSTROEMERIA, which represents devotion and mutual support between family members or friends. Its twisted leaves symbolize overcoming the trials of everyday life together. Known to also represent the idea of following your dreams and achieving your goals, it's often given as a good luck gift. Some alstroemeria can be three feet tall—it takes a strong and regal plant to be able to hold all those meanings! But oh, how beautiful!

SHARING OUR EXPERIENCES

Do you know the meaning of your name or the story behind its selection? If so, write it below.

Your name is important because the Bible says God knows us by our names, and that He calls all of us by name. Remembering a person's name upon meeting them shows you see, value, and respect them. After all, someone who loves them gave them that name.

The Bible says,

> Listen to the LORD who created you. O Israel, the one who formed you says, "Do not be afraid, for I have ransomed you. I have called you by name; you are mine." —ISAIAH 43:1, NLT

Getting to know somebody is an act that makes you vulnerable, which we all know can be scary. There are huge benefits to opening yourself up and allowing real bonds to form, and it usually begins by telling someone your name. However, the more we allow people to know us, the easier it becomes for someone to hurt us. In this session, we are going to talk about forgiving those who hurt us and seeking forgiveness from those we may have hurt.

Why is it important to forgive a person who has hurt you?

It's tempting to assume that forgiveness is about the person who did wrong, but the act of forgiving is about you, not the person who hurt you. None of us can change the past, and it's natural that the pain we carry stays with us. Forgiveness does not mean forgetting the pain or allowing someone to continue to hurt us—physically or emotionally. Acknowledging the pain, though, is the beginning of forgiveness and allows our souls' wounds to heal. When we forgive, we can begin to use our thoughts in more productive, healthy ways that allow us to move forward.

Before we move into our first activity, think for a minute about these two questions:

1. Are you still angry or upset with someone in your life—or with yourself?

2. Is there anything you are struggling to let go of or anyone you feel you need to forgive?

WARMING UP

Ever wish you could honestly tell someone how you feel? That you could stop trying to hide your hurt or deny your true feelings? In session 1, we talked about being vulnerable and exposing our inner selves. Now we are going to write what we really want to say to someone, but in a confidential and safe way. You do not have to worry about anyone accidentally seeing your letter, and you do not have to read it out loud. By the end of this activity, your letter will be destroyed.

Think for a moment of someone who hurt you or whom you may have hurt, whether emotionally, physically, or in some other way. Be honest with yourself—the one you think of could be yourself or even God. The ideal choice for this exercise would be someone whom you would like to forgive or receive forgiveness from but are finding it difficult to do so. You do not have to be ready to forgive them right now, but take advantage of this opportunity to express how you feel. Allow yourself to be authentic and truthful because this is a private letter for your eyes only. By the end of the session, it will be transformed into something completely new.

What do you want to say, even if you might not be able to say it in person? Use a pencil to write your letter on an index card or separate smaller piece of loose paper (not in your workbook). You will have five minutes to write.

How did that feel? If you'd like to share your letter, raise your hand—but you are under no obligation to do so.

CREATE

Remember our promise that your letter will be turned into something new? Let's get back to that! As an act of letting go, we are going to tear up our letters and create a piece of artwork using what we wrote, making our emotions into something beautiful and new.

Go ahead—tear up your letter! Make the pieces large or small, whatever you wish. They may be abstract shapes or defined objects or patterns. Then glue the pieces to your mixed-media art paper however you would like. There is no correct way to do this—the pieces may overlap, hang off the edges, or be right on top of one another.

We want to talk about color before we start creating. Color and emotions are directly linked to each other, and different colors have different effects on us. For example, red can increase adrenaline and make your heart beat faster. It is a color that can move you to action. Blue is a calming color, and it can even lower blood pressure. A lot of busy places, like hospitals and prisons, have blue walls. The color yellow represents happiness and joy, and when combined with the adrenaline-inducing red, has been shown to make you hungry (which is perhaps the marketing reason behind why McDonald's yellow arches are shown on a red background).

When it's time to add color to your paper, you may refer to the Color Emotions Chart on page 145 to help you choose what colors to use in your artwork. If you are stuck and do not know what color to use, think about the feelings you had when you were in the middle of the situation you wrote about—whether you were sad or angry or disappointed or something else entirely. Let your mind imagine how it feels to be forgiven or how you imagine it would feel to not carry this hurt any longer. Or maybe focus on the way the relationship feels to you in its unresolved state. Use the colors that relate to those feelings.

You may be wondering exactly how to mix the colors that match your emotions. Your paint set may have premixed colors, but all colors can be created by mixing red, blue, and yellow (which are called primary colors because they can be used to make all the other colors). For instance:

To make purple, mix blue and red.
To make orange, mix red and yellow.
To make green, mix yellow and blue.

To make any color lighter, add white. To make a color darker, add black. (When mixing in black, you only need a tiny amount to make the color a lot darker, so add it sparingly.) You do not need large quantities of paint. Adding water will make the paint thinner and help it go farther. You will find a color mixing chart on page 146 to use as a guide.

Using what you just learned about how to mix colors and what they mean, apply paints with a large brush over the glued-on pieces of your letter. Let your paints express how you feel. You may use abstract shapes or a variety of brushstrokes or paint something specific—anything you want. While you paint, let your mind reflect on the person you wrote about and think about what forgiveness looks like in this situation. Be open to what you feel God is trying to impress on your heart. You will have twenty minutes to paint.

VIEW AND APPLY

As we saw in session 1 and again today, being vulnerable can lead to beauty. Look at what beautiful things were created from places of hurt, shame, and fear!

Who would like to share their artwork and tell us a bit about their forgiveness journey?

The Bible tells us,

> Peter came to Jesus and asked, "Lord, how many times shall I forgive my brother or sister who sins against me? Up to seven times?"
> Jesus answered, "I tell you, not seven times, but seventy-seven times."
> —MATTHEW 18:21-22

Forgiveness means letting go of the hurt and anger, no matter what the sin is—even if it's difficult. It's important to understand that you can forgive without ever being in contact

with that person again. It may not happen overnight. Forgiveness is an ongoing process, and it may take a lot of hard work, but it can break a cycle of bitterness and revenge. When we can live in an attitude of forgiveness, we can move forward in a more positive direction that may even lead to reconciliation of a relationship.

We don't forgive to let someone else off the hook. Forgiving someone doesn't mean that their hurtful act didn't matter. Instead, it frees you from holding on to feelings of shame or disappointment.

But the biggest reason of all to forgive is found in the book of Ephesians:

Be kind to one another, tenderhearted, forgiving one another, as God in Christ forgave you. —EPHESIANS 4:32, ESV

When we make the choice to forgive someone for hurting us, it really isn't about them at all. It's about the fact that God has already forgiven us for all of our sins—big and small—for all the ways we've hurt one another. When we decide to let go of our anger, hurt, and resentment, we're becoming more like Jesus and operating as vessels of the immense grace that has already been poured out onto us.

LET'S CLOSE OUR TIME TOGETHER IN PRAYER.

Lord Jesus, help us to not carry pain or bitterness. Please give us the grace and power to hand over our hurts to You and forgive those who have caused us pain. You already know all the ways we have hurt others. We are sorry, Lord. Please forgive us. Your immense grace and mercy will bring healing to our hearts. In Your name we pray, amen.

REFLECT AND REMEMBER

Here's what past participants have said about their experiences. Read through their words, and then add your own brief reflections to help you remember what the session was all about.

WHAT PEOPLE SAID THEY LIKED BEST ABOUT SESSION 2

FORGIVENESS

- "This helped me find myself more, open up, and realize I really need to forgive my mom to move forward. I got emotional but this was well needed. This really touched my heart and will help me heal. Thank you for caring and showing us we matter."
- "This session was a godsend to my life. It has me stepping into a creative side that I didn't know I even had."
- "It gets my brain thinking about the things in my life I tend to stuff in the back of my head."
- "Creating something beautiful from something that has so much pain."
- "The emotional release and forgiveness of self."
- "It opened my eyes and heart."

WHAT I SAY

REINFORCE

This completely optional exercise is designed to help you retain what you just learned. If it is fun for you to do, complete this during the coming week, but do not feel any pressure. You are in control and can do as much or as little as you like.

The idea behind the flowers we're sharing in each session is that each flower has specific meanings. On pages 141–142, you will find a list of flowers and their meanings. As you look through the list, see if any of the flower meanings spark a connection to someone in your life. Are there things you can't or won't say to them that you wish you could?

Along the left-hand side of the chart that follows, write down three or four names of people in your life (family, friends, coworkers, partners, exes, etc.) who have forgiven you or whom you are trying to forgive. Then on the right-hand side, beside the names, write the name of the flower you wish you could send them or draw a picture of it. Feel free to jot reminders to yourself about the flowers' meanings, but no one else needs to know why those flowers are appropriate. This is just for you.

PERSON	FLOWER

COLLABORATIVE HAND ART
Reconciliation

ART SUPPLIES FOR SESSION 3

- ☐ 1 large sheet of mixed-media art paper
- ☐ Black permanent marker
- ☐ Colored pencils
- ☐ Pencil sharpener
- ☐ Pencil

Stephanie Logan Segal

 WATCH A VIDEO from Martha and Stephanie about this week's session at tyndale.life/create_session3.

LOOKING AHEAD

Reconciliation is the process of mending broken relationships. For today's project, we're going to create "hand art" while processing the meaning of and need for reconciliation in our relationships.

EXAMINE

LOOKING INSIDE

> Forgiving and being reconciled to our enemies or our loved ones are not about pretending that things are other than they are. It is not about patting one another on the back and turning a blind eye to the wrong. True reconciliation exposes the awfulness, the abuse, the pain, the hurt, the truth. It could even sometimes make things worse. It is a risky undertaking, but in the end it is worthwhile, because in the end only an honest confrontation with reality can bring real healing. Superficial reconciliation can bring only superficial healing.
> —ARCHBISHOP DESMOND TUTU

Are you currently in a relationship with a friend, family member, or partner that could be better? You're not alone. Nearly every relationship can benefit from prayer and reconciliation on some level. Let's see what the Bible tells us about working to make peace in relationships.

> All this is from God. Through Christ, God made peace between himself and us. And God gave us the work of bringing people into peace with him. I mean that God was in Christ, making peace between the world and himself. In Christ, God did not hold people guilty for their sins. And he gave us this message of peace to tell people. —2 CORINTHIANS 5:18-19, ERV

Reconciliation may be difficult, but it is good and holy work for which God has equipped us.

Lord God, please bring us all together as one people—reconciled to You, reconciled with one another, healed, and forgiven. Thank You for giving us the desire to pursue the healing of our important relationships. We humbly ask You for the love, grace, and wisdom to receive and offer forgiveness as we move forward to do the work needed to make peace with each other. Help us to trust You. In Jesus' name, amen.

PRESENTATION OF FLOWERS

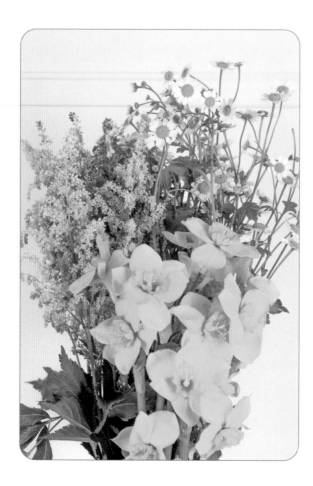

As you've learned, people in Victorian times used flowers to convey messages and feelings. We love that concept, so we also like to talk about the meanings of specific flowers that relate to each session's topic.

Today, we are starting with the ASTILBE, a flower that looks delicate but is actually very strong. It says, "I'll be waiting for you," and symbolizes patience and dedication for a loved one.

We also have CHAMOMILE, which means energy, strength in adversity, and patience. Chamomile is also used as an herbal remedy for all kinds of ailments.

The last flower is the DAFFODIL, which represents new beginnings and eternal life.

When you look at these flowers, we hope you absorb our message to you today: You are strong and able to do the hard work in relationships. We hope you will show patience and dedication when it comes to mending and growing relationships, even if it takes a long time to see the results. When you face troubles and trials, especially in relationships, these attributes will give you the strength and patience to work toward reconciliation. We're grateful that God offers all of us opportunities for new beginnings in all things, as well as eternal life with Him, the one who loves you so very much.

Love,

MARTHA & STEPH

SHARING OUR EXPERIENCES

To get us started, let's take a moment to think about this question: Is there someone in your life who has hurt you, someone you have hurt, or both? Reconciliation—the process of making a broken or damaged relationship right again—includes three steps:

1. Confession (an admission of wrongdoing, which requires honesty and vulnerability)

2. Repentance (a sincere apology and commitment to change)

3. A response of forgiveness

Reconciliation results in a reestablishment, change, or healing of the relationship, moving away from a state of bitterness or brokenness to a place that is positive and peaceful. This may require creating boundaries that help support a healthier connection. However, there may be good reasons why you don't wish to reconcile—for example, you experienced a relationship where there were unhealthy addictions or abusive behaviors. Reconciliation doesn't require putting yourself back into a bad situation. Establishing a newer, healthy relationship can take place from a distance and may include making changes in your life that release you from past patterns and enable you to move forward.

Each week, we look to the Bible as a guide for how to grow and heal. In Colossians we read,

> Bear with each other and forgive one another if any of you has a grievance against someone. Forgive as the Lord forgave you. —COLOSSIANS 3:13

It is possible for forgiveness to occur in your relationships with or without reconciling with the wrongdoer. Forgiveness, which we discussed in the previous session, is different from reconciliation. It may or may not lead to a reconciled relationship, but if there is unforgiveness (in either direction), it is nearly impossible to reconcile. Forgiveness is a beautiful thing and must come first, as we read in Ephesians on page 28. But Jesus encourages us to go a step further. That additional step is also found in Ephesians, pared here with the previous session's verse.

> Get rid of all bitterness, rage and anger, brawling and slander, along with every form of malice. Be kind and compassionate to one another, forgiving each other, just as in Christ God forgave you. —EPHESIANS 4:31-32

Steps to begin the process may include:

1. An honest confession of what you've done wrong.

2. A heartfelt apology made with a sincere heart.

3. Returning to its rightful owner something that isn't yours.

4. Paying something back that you owe.

5. Saying, "I hurt you and I'm sorry. I want my words and actions to be encouraging to you and not harmful."

6. Saying, "You hurt me, but I am going to let go of anger and bitterness in order to move forward."

GET READY

WARMING UP

Before we begin our art project, let's get our creativity flowing with a warm-up activity. It's not meant to necessarily result in a good piece of art. It's more about the process.

On the following two pages, use your marker to make circles of various sizes until the space is filled. Make sure the circles do not overlap. Try to draw them in both directions—clockwise and counterclockwise. Make lots of circles of all sizes. Drawing circles is not as easy as you might think. Notice how the circles become harder to draw the bigger you make them. While you're drawing your circles, think about the questions on the next pages.

Who has
caused you hurt
or is someone you
have hurt?

What are some steps
you can take to start the
reconciliation process?

How did you feel or what thoughts did you have when you were drawing the circles and thinking about hurts and reconciliation? Take a moment to discuss this as a group.

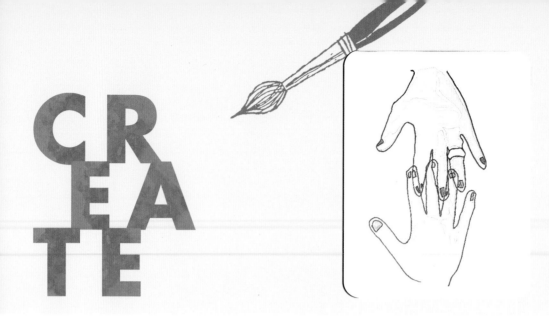

CREATE

Our art project today is an expression of reconciliation. The first step is to think of a relationship in your life that is in need of reconciliation, in the process of reconciliation, or one in which reconciliation has already happened. Based on that relationship, we are going to create "hand art" using a marker and colored pencils.

Let us explain the project before you begin. You will trace both hands onto a large piece of paper. The first will represent you and the second will represent a person who has either caused you hurt or has been hurt by you. When you are choosing where to place your second hand, think about where you are now—or where you hope to be—in the reconciliation process. For example, if you feel that reconciliation is possible (or has already happened), you might place the second hand on top of the first hand so that they appear intertwined.

Use the placement of the hands on the page as a way to express your situation: If one person is ready to reconcile but the other isn't; if you're each moving in different directions, unlikely to reconcile; or if the hands are perfectly aligned as though ready to fit together. There are a lot of different possibilities here for your hand placements. Feel free to ask if you need some guidance.

Once you are ready to begin, turn your paper so it is in a landscape (horizontal) orientation and use your marker to trace one hand onto your piece of paper. This hand represents you. Make sure to place your hand on the paper in a way that allows space for another hand on the same page. Next, trace your other hand onto the same sheet of paper. This hand represents either the person who has caused you hurt or the person you have hurt. If you're thinking of multiple people, you may trace your second hand multiple times. You have five minutes to trace your hands. We will stop the music when the time is up.

Now that you have the hand outlines, let's think about the ways color and emotions are linked to each other. As you learned in session 2, different colors have different effects on us. For example, red can indicate passion, love, danger, and even anger, all emotions that can move you to action and make your heart beat faster. But pink, which is red mixed with white, shows a vulnerable tenderness. Green symbolizes growth and harmony, safety and healing.

Refer to the Color Emotions Chart on page 145 for an overview of emotions represented by different colors and choose colors to represent your feelings. Using your colored pencils, spend fifteen minutes coloring your hand outlines—whether abstract or realistic, using words or images, boldly or subtly—in a way that reflects how you feel about the relationship.

VIEW AND APPLY

Next, we are going to work together to turn our drawings into a piece of collaborative art. Everyone must put their drawing with the others, but everyone does not have to share their thoughts. Please place your drawings neatly touching each other, forming a large rectangle or square shape on the floor, like a large mosaic. If possible, line up the drawings so that the same number appear in each row or column, but if not, place the extra drawings in the center top or bottom row.

Now stand back and notice how the individual pieces combine to create one large piece of art. Feel free to have fun with it and try some different arrangements. This can help you see the beauty in reconciliation among larger groups of people.

Would anyone like to point out your drawing, tell us where you are in the reconciliation process, and describe the next steps you would like to take? After this session, you may want to write a couple of sentences below about the next steps you hope to take in order to hold yourself accountable.

Reconciliation takes time and often begins with ourselves (not the other person in the relationship). When we let go of bitterness and anger, the resulting change in attitude sets us free, perhaps creating space for restoration of a relationship—even if the other person isn't yet ready for change.

God created us for connection—to each other and to Him. That's why we're told in Scripture to forgive; when we can restore broken relationships, we are living as Jesus wants us to live. We can make connections that strengthen us, rather than hold us back. We can learn to love and encourage one another and be part of the whole body of Christ when we are all working to be healthier in our relationships.

As you think and pray about reconciliation, there is an important relationship to remember. Sometimes there is something standing between us and God. Don't forget that you can take steps toward reconciliation with Him, too, by being honest and vulnerable. That is where you will find the greatest of all healing, and you can be sure your prayers will be answered because God wants nothing more than a connection with you. This psalm explains the reason for this great blessing:

> The LORD is compassionate and gracious, slow to anger, abounding in love. He will not always accuse, nor will he harbor his anger forever; he does not treat us as our sins deserve or repay us according to our iniquities. For as high as the heavens are above the earth, so great is his love for those who fear him; as far as the east is from the west, so far has he removed our transgressions from us."
> —PSALM 103:8-12

WILL YOU PLEASE JOIN TOGETHER IN PRAYER BEFORE WE LEAVE TODAY?

Lord God, when You sent Your Son to bear our sins for us, You extended the ultimate forgiveness to Your people. But there are times that we hold on to our grudges or fail to offer that forgiveness to others (or ourselves). Soften our hearts to allow us to move toward reconciliation and live in a right relationship with You. We know we can't go backward in time, only forward, so help us to face our regrets but not dwell on them. Instead, we ask for Your grace as we seek healing, positive change, and reconciliation. In Jesus' name, amen.

REFLECT AND REMEMBER

Here's what past participants have said about their experiences. Read through their words, and then add your own brief reflections to help you remember what the session was all about.

RECONCILIATION

- "I like hearing about other people's healing. It helps me see them differently."
- "I liked listening to the music and reflecting on my reconciliations. It was relaxing and felt good to let go of my bitterness."
- "It's enjoyable to discover different meanings in the little things."
- "I've realized how important it is to my own recovery to fix what's broken and heal and move on."

WHAT I SAY

REINFORCE

This optional exercise is designed to help you retain what you just learned. If it is fun for you to do, complete this during the coming week, but do not feel any pressure. You are in control and can do as much or as little as you like.

When we placed our artwork together on the floor to view, we literally created a piece of collaborative art—a bunch of hands, all linked together—for this session. Although God created us to connect with one another, sometimes we push relationships to the back burner when we're busy, tired, or stressed. Spend some time in prayer asking God the following question, then jot down your responses and ideas:

Lord, how can I build deeper connections with others, and who are you calling me to connect with?

If you don't have any ideas, make a list of people to whom you could send cards and set a goal to mail one a week. Or invite one person over for coffee. Or send a text to let a friend know she's on your mind. If you wish, grab an extra sheet of mixed-media paper. Fold and cut it to fit in an envelope and pray for the future recipient as you decorate the front of the card. You may want to draw circles like you did in this session's warm-up and fill them with color. Or you may want to dab paints onto the page in an abstract pattern or even in the shape of a coffee cup if your note includes an invitation to coffee. However you feel inspired to connect with someone else, you have our encouragement and blessing to take a chance and reach out.

SESSION 4

HOUSE OF EMOTIONS
Emotions

ART SUPPLIES FOR SESSION 4

- ☐ 2 sheets of mixed-media art paper
- ☐ Black permanent marker
- ☐ 1 set of watercolors
- ☐ Large acrylic paintbrush
- ☐ Colored pencils
- ☐ Disposable cup or water container
- ☐ Paper towels or rag for cleanup
- ☐ Pencil

Stephanie Logan Segal

Prep for the facilitator before the session

Find a copy of Shel Silverstein's poem "Enter This Deserted House" to read aloud during this session. It's included in his book *Where the Sidewalk Ends*, or you can also find it online at poeticous.com/shel-silverstein/enter-this-deserted-house.

Watch a video from Martha and Stephanie about this week's session at tyndale.life/create_session4.

45

LOOKING AHEAD

In this session we'll identify and explore our emotions as we create a drawing of rooms in a house. We'll use objects and color to portray our various emotions. Remember, to make this a safe space for all, please keep what is shared confidential. Do not repeat it to others.

EXAMINE

LOOKING INSIDE

> Some emotions don't make a lot of noise. It's hard to hear pride. Caring is real faint—like a heartbeat. And pure love—why, some days it's so quiet, you don't even know it's there. —ERMA BOMBECK

Emotions are present in everything we say and do, and there is a time for each of them, but sometimes our emotions cloud our judgment and get in the way of making the best choices. Our verse for today comes from Ecclesiastes:

> To every thing there is a season, and a time to every purpose under the heaven: . . . A time to weep, and a time to laugh; a time to mourn, and a time to dance. —ECCLESIASTES 3:1, 4, KJV

SHALL WE PRAY?

Dear God, our emotions play a major role in the words we speak and the actions we take. Help us to recognize our different emotions as they arise. When they could be harmful to ourselves or others, help us through Your Spirit to replace them with Your love, joy, peace, compassion, and self-control. Lead us to act kindly toward others. In Jesus' name, amen.

PRESENTATION OF FLOWERS

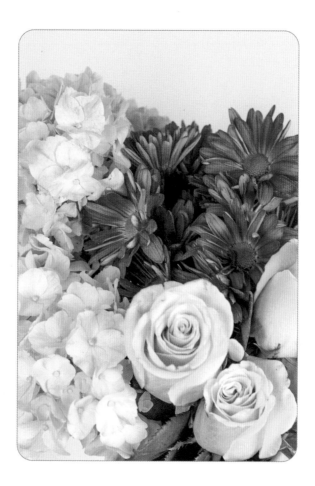

Mary Lennox, in the 1993 film adaptation of Frances Hodgson Burnett's *The Secret Garden*, says, "If you look the right way, you can see that the whole world is a garden." Let's take a look at the flowers we've selected for today's workshop and the meanings behind this little piece of the world's gardens.

First, we have the HYDRANGEA, a flower that symbolizes heartfelt emotions and indicates gratitude for being understood.

The CHRYSANTHEMUM represents optimism, honesty, joy, rest, and longevity. It's also known to express love and loyalty. Just as love comes in many forms, mums come in many different colors.

Our message through these flowers is this: We hope that your life will be filled with grace, happiness, and healing in every area. May you remain optimistic and joyful despite outside circumstances, finding beauty in each moment. We hope you will learn to recognize your emotions and use them in a way that impacts your daily life—and the lives of others—in positive ways. As you acknowledge tumultuous emotions, we pray that you will treat yourself with kindness and gentleness.

Love,

MARTHA & STEPH

The final flower is the beautiful PALE PINK ROSE, which means gratitude, grace, and joy. Its soft color expresses its other meaning: gentleness.

SHARING OUR EXPERIENCES

Please take a moment to read this statement and fill in the blanks:

I often feel _____ because _____.

For example, "I often feel insecure because I think that I am not smart enough." Or "I often feel happy because I'm grateful for my family."

A quick note to the facilitator

As people in the group share their responses out loud, write the emotions identified in the first blank on a board or easel. Use one marker color to represent negative emotions (such as fear) and another for positive emotions (such as joy). For neutral emotions, such as surprise, add them to either list based on context. (Refer to the List of Emotions on page 143 for examples.)

WARMING UP

Before we begin, let's go over the Color Emotions Chart on page 145. You may recall from session 2 that color and emotions are directly linked to each other, and different colors have different effects on us. Red can signify passion or anger and subsequently increase your heart rate. Blue is a color that represents stability, calm, and peace—but it's also sometimes linked to feelings of depression (i.e., "feeling blue"). Yellow represents joy and happiness. Green, as is found in nature, represents growth and life and vitality.

Close your eyes for a moment as you think about some of the emotions you are feeling right now, and then choose colors that represent how you think your body would look if it revealed your emotions. Even if you're not sure, trust your gut and go with how each color makes you feel.

As a warm-up activity, we are going to paint an abstract image of our bodies using an interesting, fun technique called a watercolor bleed. Please read the following numbered directions before beginning. You have ten minutes to complete this three-part exercise.

1. The illustrations on these two pages are miniaturized samples. Your illustration should fill an entire page. You can either draw the body template freehand directly on your mixed-media art paper with a black marker or trace the larger body template on page 147. If you choose the second option, place the body template underneath your mixed-media art paper. You should see a faint outline through the paper. Trace this shape with a black marker to make your own outline of a body.

2. One of the hallmark characteristics of watercolor paints is the way the colors run and bleed into each other. This requires plenty of water. To begin the watercolor bleeding, use only clean water. With no color on the brush yet, fill the entire area inside your body template with water. Try to stay inside the lines and use plenty of water so that it does not dry too quickly.

3. While the shape of the body is still wet, begin to add drops of the watercolors using colors that represent your emotions. You will need to add a lot of water to the brush and the color you want to use. Dip your brush in the color several times to fill the bristles with plenty of pigment so that the color will expand when it is placed on the wet surface. Let the color bleed throughout the body shape, then dunk your brush in water to clean it before repeating the process with another color to create a tie-dye effect that is uniquely yours.

How did you feel when you were painting with your colors? Take a moment as a group to discuss this.

Emotions are a complicated part of who we are, but the world would be pretty boring without them.

Emotional intelligence, or EQ (emotional quotient), refers to the ability to identify and manage your own emotions, as well as the emotions of others. Identifying them can give you a jump start in dealing with situations as they arise and provide tips for increasing your EQ throughout the day—both of which will lead to more positive outcomes.

Everyday examples of a good or healthy EQ include:

- Cheering yourself up by doing something you enjoy (walking, reading, taking a bath, listening to favorite music).
- Calming yourself down by doing breathing exercises or praying.
- Walking away from a frustrating situation.

You can also show EQ toward someone else in many ways, including:

- Allowing your friend to express her emotions without judging her.
- Lending a listening ear to a sad family member.
- Calming down an overexcited child or an adult.

Think about the last time you were angry. Can you identify your underlying emotions? For example, did you feel hurt or frustrated or powerless?

As you prepare to write your emotions in the space below, look at the List of Emotions on page 143 and see if any of them apply to you. What does this tell you about the way you handle your anger?

Having emotions—both positive and negative—is a normal part of being human, and the emotions themselves aren't fundamentally good or bad. Without sadness, anger, fear, and grief, we would not be who we are. Identifying negative feelings and the causes at their root can help us offer grace to ourselves and others. When we learn to control our actions and reactions, we can reroute our thinking and transform negative emotions into positive ones.

CREATE

For our project today, we are going to use our imaginations to create a house of emotions. Your imagination is uniquely yours. No one else will "see" exactly what you do. Speaking of imagination, we're going to get our imaginations started by listening to a poem by Shel Silverstein called "Enter This Deserted House." Close your eyes as you listen and let your mind envision the place described in the poem.

What sort of house did you imagine? What do the rooms look like? Is this house really deserted? What emotions did the poem make you feel?

Emotions can take up a lot of space in our lives. Some days, we may experience every emotion imaginable, as if we're riding on a roller coaster, and other days our emotions may be more predictable. Our emotions are all different, and they may change with our circumstances.

Now that you've imagined the house in the poem, you are going to create a new house of your very own, built from your emotions. How do you feel right now? What emotions have you recently experienced? Are you sad, happy, anxious, afraid? Weepy, embarrassed,

indecisive, confident? Loving, resentful, optimistic, bitter? Strong, inspired, distracted, or fed up? Review the emotion words we identified earlier if that is helpful.

Identify at least two but no more than five emotions to represent. Then imagine that each emotion is a different room in your house, similar to the sample artwork you see here.

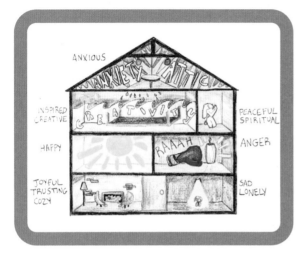

You'll start drawing in a moment, but let your imagination do some of the work beforehand. Imagine what shape your house will be. How many floors will it have? Is there an attic or a basement? The largest room in your house will represent the emotion you are feeling the most. The smallest room will contain an emotion you are feeling slightly.

You'll use colored pencils to draw your house onto a clean sheet of mixed-media paper. Once you've drawn the shapes of the rooms, you will add colors and items, such as furniture or light fixtures, to decorate the rooms and further express the emotions.

You don't have to draw a perfect architectural structure or re-create literal items you would find in a real house. Feel free to use stick figures, abstract shapes, symbols, or even just color. If you'd like, you may use the Color Emotions Chart on page 145 to help you choose colors for your drawing.

It is a good and healthy thing to be in touch with your emotions, so give yourself permission to feel what you feel, and for now, suspend judgment about whether a particular emotion is good or bad.

You will have twenty minutes to complete your artwork. We will stop the music when the time is up.

VIEW AND APPLY

Part of the beauty of doing these projects together is the opportunity to share with each other. Please form small groups and take turns sharing your House of Emotions drawings. As you go through your rooms, briefly discuss what is causing each emotion. You will have ten minutes to share.

Learning to identify our negative emotions helps us process them in healthy ways. If we don't deal with emotions as they arise, they can build up and cause us to escalate conflicts or

make rash, destructive decisions. When we find ourselves feeling upset, frustrated, stressed, or angry, we don't have to let those feelings consume us.

Let's see what God's Word says:

> The fruit of the Spirit is love, joy, peace, patience, kindness, goodness, faithfulness, gentleness, self-control; against such things there is no law.
> —GALATIANS 5:22-23, ESV

In other words, when we reflect the Holy Spirit, our responses will be filled with those things. When our emotions or responses are unhealthy or harmful, we don't need to despair, though. God is faithful to help us change.

LET'S PRAY.

Lord God, we thank You that Your Word serves as a guide for the best way to live—a way that's healthy for us and more like You. We know that our emotions impact not only ourselves but others as well. When we feel upset, angry, frustrated, or stressed, help us to remember that You have enabled us to be free of the hold of those negative feelings. You want us to dwell in a house of positive emotions. Transform the "rooms" we live in and make us more like You. Thank You for giving us hope and the ability to change. In Jesus' name, amen.

REFLECT AND REMEMBER

Here's what past participants have said about their experiences. Read through their words, and then add your own brief reflections to help you remember what the workshop was all about.

EMOTIONS

- "I loved being able to look within myself and paint my emotions."
- "Being able to express my feelings by drawing the body and seeing the colors of my emotions."
- "Expressing myself through the bleeding watercolors."
- "Using watercolor as a way to talk about the emotions and hang-ups that fill our houses. This is amazing!"

WHAT I SAY

REINFORCE

This optional exercise is designed to help you retain what you just learned. If it is fun for you to do, complete this during the coming week, but do not feel any pressure. You are in control and can do as much or as little as you like.

You just drew a house of emotions that represents what you are feeling inside. Let's get more literal now and look at your actual house or living space. What can you do (without spending money) to enhance or improve the emotions you feel there? Consider the emotions in the fruit of the Spirit verses as well as the happier rooms in your drawing.

The changes don't have to be large or obvious to anyone else. They're just for you. For instance, maybe your sewing machine is set up in the guest room and you feel creative when you work in there. Hang up fabric samples or a bulletin board of photos to inspire you. If your happy place is a cozy chair in your living room, you might paint something on a small canvas, large rock, or scrap piece of wood to reinforce those feelings of contentment: "Home is where the heart is." Or "Gratitude makes what I have into enough."

On the other hand, if you feel anxiety in a particular space (maybe the desk where you pay bills or work from home), perhaps you want to display a simple reminder to yourself: "God's got this." Or "Just breathe. It will be okay."

You might rearrange a room to create an intentional prayer spot, with a small basket of books, a journal, and a Bible next to where you sit. Or free up a corner in which you can create the beaded jewelry you've been thinking about making. Your change might be as simple as placing a soft blanket across the back of your chair to remind yourself that you are worthy of comfort. You don't need extra rooms; this is more about making room inside your heart to remember.

Before you begin, pray and thank God for all that you have, and ask Him to show you how to bring more positive emotions into your daily life.

SESSION 5

YOUR STORY
Empathy

ART SUPPLIES FOR SESSION 5

- ☐ 2 sheets of mixed-media art paper
- ☐ Index card or loose sheet of paper
- ☐ Colored pencils
- ☐ Pencil sharpener
- ☐ Black permanent marker
- ☐ Pencil

Stephanie Logan Segal

Watch a video from Martha and Stephanie about this week's session at tyndale.life/create_session5.

LOOKING AHEAD

In this workshop, we will explore the topic of empathy by creating a storyboard of emotions. We'll learn the difference between empathetic and nonempathetic responses and share personal stories. It is especially important to listen patiently and respond to one another with compassion so that we can communicate deeply and openly.

EXAMINE

LOOKING INSIDE

> The ground is level at the foot of the cross.
> —CHUCK COLSON, FOUNDER OF PRISON FELLOWSHIP

Because this workshop sometimes goes very deep and may remind participants of painful experiences, we want to remind everyone that our goal is to provide a safe space in which everyone can be vulnerable and feel comfortable creating and sharing. To create this environment, we all must be willing to keep what is shared confidential and not repeat it after leaving here.

Please be encouraging and positive with your comments and show your love for one another with your respectful, careful handling of sensitive stories. In this session, we are giving positive feedback only.

Have you ever shared your feelings about an experience and had someone respond in a way that made you feel understood? There's just something about this that makes us feel like we're not alone. On the other hand, have you ever had someone share words that didn't help but actually made you feel worse—even if they meant well?

The Bible encourages us in Ephesians:

> Do not let any unwholesome talk come out of your mouths, but only what is helpful for building others up according to their needs, that it may benefit those who listen.
> —EPHESIANS 4:29

It makes such a difference what words people speak into our lives, but it's not always easy to offer only uplifting words to others. We've all stumbled with our words at times—or perhaps had way too many of the wrong ones come out of our mouths!

Although we may never achieve perfect control over our tongues, just imagine the radical change that could happen in our relationships if acquaintances and friends, parents and children, husbands and wives would try to apply this verse.

LET'S PRAY TOGETHER.

Lord God, Your Word says that "out of the abundance of the heart the mouth speaks." Fill our hearts with kindness and compassion so that when we overflow, it is with love and encouragement and not negativity. Help us all to be quick to listen and slow to speak, and teach us how to offer uplifting words when we speak to one another. Let all that we do glorify You. In Jesus' name, amen.

PRESENTATION OF FLOWERS

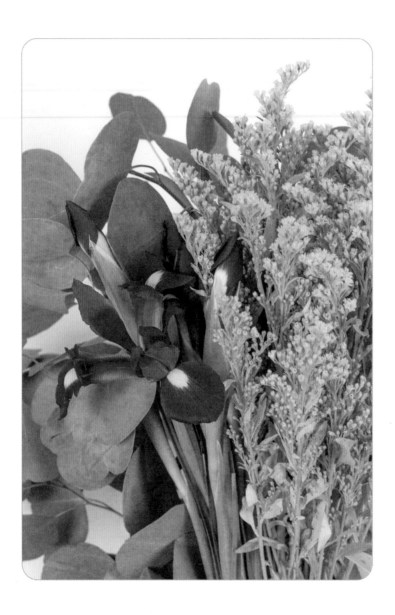

Today we'll start with sprays of GOLDENROD, which represents careful encouragement—and happens to be a bright, sunny yellow, which typically brings joy.

The next flower we have for you today is the IRIS. Just as the flower comes in a wide range of colors (blue, purple, lavender, yellow, white, and more), the iris represents a variety of ideas, like faith, hope, wisdom, trust, and encouragement.

We also have EUCALYPTUS, which symbolizes healing, connection, and leadership. The eucalyptus tree's inner layer holds it together while the outer surface is strong, so it represents self-protection.

Today's flowers tell you this: Just as the bright yellow goldenrod exudes joy, we hope your life is filled with joy because we believe that is more than possible. As eucalyptus has so many health benefits, we pray for emotional healing and for the strength to reveal your deep inner self. You were made for connection with others, and we pray that you will lead others along this path with faith, hope, wisdom, trust, and encouragement, as represented by the iris.

Love,
MARTHA & STEPH

SHARING OUR EXPERIENCES

To begin our discussion, please answer the following question: How do you know when someone understands what you're going through?

Empathy can be defined as heartfelt listening, relating to one another, or putting yourself in someone else's shoes. Some of us do these things naturally, but for many of us, it's a skill that we must develop by intentionally practicing it.

On your index card or loose sheet of paper, write something that is currently worrying you or causing you anxiety. Rather than a vague, abstract concept (like climate change or illness), your answer should be a specific and personal concern that you don't share with many people. Please do not write your name on the card—your answers will remain anonymous, so we hope you will feel free to be open and honest. You will have five minutes. We will stop the music when the time is up. Turn your card facedown when finished.

Your facilitator or a volunteer will collect and shuffle the cards without looking at them, then read two or three cards out loud—one at a time. Listen closely and think about how the person who wrote it might be feeling. Jot down some of your answers below as one person writes them on a whiteboard or large pad of paper. Take a few minutes to respond after each card is read.

"I imagine this person is feeling _____."

Raise your hand if you would like to share your answer, but please don't raise your hand if we're discussing your card. Allow others the chance to respond to your situation.

By imagining someone else's feelings in a situation, you are practicing empathy, and by responding in an encouraging, nonjudgmental way, you are learning what it looks like to show empathy to another person. What benefits might come from practicing empathy? Does it help you care more about other people's feelings, make healthier decisions, build deeper relationships?

Write your response on the following lines.

The Bible describes ways we can show empathy to others and why we should:

> Therefore, as God's chosen people, holy and dearly loved, clothe yourselves with compassion, kindness, humility, gentleness and patience. —COLOSSIANS 3:12

When we let God into our lives and He begins to change our hearts, our response will naturally become more compassionate and kind. But to start, we must make a choice to willingly wrap ourselves with these attributes.

GET READY

WARMING UP

For this session's warm-up activity, pair up with a partner. We encourage you to speak openly and listen without interrupting, judging, or criticizing. Please maintain confidentiality and do not share this conversation outside of this room. You might notice this warm-up looks a little different than in previous weeks. With your partner, share a personal story about one of these topics:

- A struggle with mental health, such as addiction or depression.
- The birth of a child.
- The death or illness of a loved one.
- An issue with a current relationship.
- Loss of a job or change of career.

After one person shares her personal story, her partner will give brief empathetic feed-back. Think back to the feelings identified in the fill-in-the-blank exercise we did earlier to help you.

Begin at least one of your feedback responses with either "I noticed you were feeling . . ." or "I hear you saying . . ." Be thoughtful and intentional about responding to each story in a way that shows you have listened to the story and have tried to imagine what it would be like to walk in their shoes. It is good to repeat something the storyteller says because it shows that you were listening.

Do not steer the conversation toward your own experiences, but instead keep the focus on the person who has just shared. Speak only words that are positive, meaningful, and encouraging.

For example, imagine someone shared this story: "My best friend of twenty years betrayed me. It makes me sad and angry because I was always a good friend." Some good, empathetic responses would be: "I understand you feel sad because you were betrayed. This makes me feel sad for you." Or "I hear you saying you were a good friend to this person for a long time. My heart hurts for you because that must have been a huge loss."

The point of empathy is to come alongside someone or connect with how someone is feeling, no matter what place that person is in. It is important to remember empathy is not giving advice. Do your best to avoid nonempathetic responses, such as:

- "I think you just need to forget about it or distract yourself so you're not thinking about it." This is not a good response because the storyteller is not seeking advice.

- "It'll be okay. At least you have other friends." This is not an empathetic response because it minimizes the storyteller's experience.

- "My old friend was gossiping about me to everyone. She had no right to do that to me." You may feel like you're connecting to the storyteller with a shared experience but, in reality, this is not a good response because it brings the focus to you, causing the other person to feel unheard and upstaged.

You will have a total of four minutes for each person's story and the partner's empathetic response; then you will swap roles and have four more minutes for that story and response. All in all, this will take approximately eight minutes.

CREATE

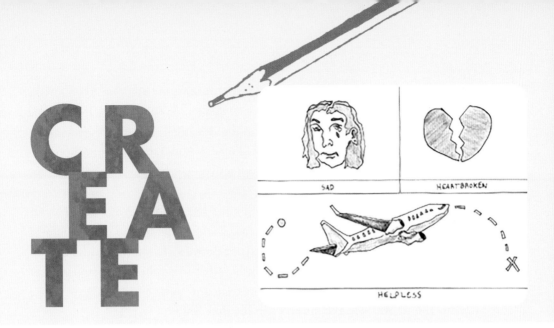

This session's art project will be a storyboard created using colored pencils, and it will build on what we just discussed. Think about the story you just heard (not your own). What stands out to you? Identify two to four emotions that you imagine the storyteller felt. For inspiration, see the List of Emotions on page 143.

Using your pencil and a ruler, divide your page into the appropriate number of spaces, one for each emotion you identified. Write the names of the emotions at the bottom of the blank spaces. Refer to the sample storyboard artwork above to get started.

Inside each box, draw the emotion or a scene that represents the emotion. If you wish, you may also take elements of the story and incorporate them into your drawing, like a comic book. The point of this isn't to create a lifelike drawing. Use stick figures if you want; add speech bubbles or just fill the space with words; be literal or abstract. The most important thing is that this storyboard should represent the feelings you imagine *the other person* felt in the situation they shared with you.

As you draw and color your storyboard, keep in mind what you've learned so far about the emotions associated with different colors. You may want to refer to the Color Emotions Chart on page 145 to help you choose colors for your drawing. If you are unsure how to select colors, think about how your partner might have felt when the event happened, as well as how she may be feeling now, and use colors related to those feelings. You will have twenty minutes, and we will stop the music when the time is up.

VIEW AND APPLY

Thinking about the emotions experienced by your partner in this activity may be uncomfortable. You may be tempted to come up with solutions to "fix" things or to judge someone in the story. The emotions may remind you of your own hurts or regrets. You may acknowledge the emotions to yourself, but then let them go. Don't dwell on them or internalize them. Instead, focus on the following positive truths:

- God loves both of you right where you are, just as you are, no matter what either of you has done.
- God's grace and forgiveness cover everything.
- You do not have to remain in a place of hurt. God will help your soul heal.
- When you feel and express empathy to others, they are likely to feel less alone.

As you respond in positive ways, you are exhibiting the fruit of the Spirit we talked about in session 4. First Thessalonians says,

> Therefore encourage one another and build each other up, just as in fact you are doing. —1 THESSALONIANS 5:11

It's a beautiful thing when we are able to connect with another person's experience and try to understand how they are feeling. It helps build them up and give them hope that they will come to a place of acceptance regarding past situations.

But as much as we wish we could say otherwise, we can't always count on someone else to give us the perfect response and understand our hearts. People will sometimes simply not know what to say, or they may have a hard time imagining what it would be like to walk in another person's shoes.

Even if the person sitting across from us doesn't understand, there is one person who always knows exactly how we feel. Jesus, the "friend who sticks closer than a brother" (Proverbs 18:24) tells us, "Never will I leave you; never will I forsake you" (Hebrews 13:5). Many times, we think of God as a far-off concept, but the truth is that Jesus longs to be your close companion, to walk beside you in the good times and the bad. He will help you carry your emotions and heal from your pain, and you will want to share God's healing power and comfort with others.

This is something worth celebrating! As the Bible says,

> Praise be to the God and Father of our Lord Jesus Christ, the Father of compassion and the God of all comfort, who comforts us in all our troubles, so that we can comfort those in any trouble with the comfort we ourselves receive from God.
> —2 CORINTHIANS 1:3-4

LET'S CLOSE OUR TIME TOGETHER IN PRAYER.

Lord God, You are the God of mercies and the giver of grace. Help me to turn to You for the comfort I need and share with others the comfort I receive from You. Please give me the empathy to be a godly friend and the ability to speak encouraging words that build others up and show them how much they are loved, just as You do to me. In Jesus' name, amen.

REFLECT AND REMEMBER

Here's what past participants have said about their experiences. Read through their words, and then add your own brief reflections to help you remember what the workshop was all about.

WHAT PEOPLE SAID THEY LIKED BEST ABOUT SESSION 5

EMPATHY

- "What fun to share and learn a positive way to respond that is therapeutic and uplifting and healing!"

- "The chance to express our feelings among each other. We were able to be more sympathetic than usual and show and express more empathy."

- "Spending time as a group to share our deep thoughts with each other."

WHAT I SAY

REINFORCE

This optional exercise is designed to help you retain what you just learned. If it is fun for you to do, complete this during the coming week, but do not feel any pressure. You are in control and can do as much or as little as you like.

Sometimes it's difficult to remember that Jesus was both fully human and fully divine. He experienced life on this earth so that He can relate to our own experiences. Look through Scripture for evidence showing that Jesus experienced human emotions just like we do. Write out the verses in a journal, and next to each one, identify the emotions He felt.

Here are a few to get you started.

Jacob's well was there, and Jesus, tired as he was from the journey, sat down by the well. It was about noon. —JOHN 4:6

After fasting forty days and forty nights, he was hungry. —MATTHEW 4:2

Jesus wept. —JOHN 11:35

Father, if you are willing, take this cup from me; yet not my will, but yours be done. —LUKE 22:42

When he saw the crowds, he had compassion on them, because they were harassed and helpless, like sheep without a shepherd. —MATTHEW 9:36

At that time Jesus, full of joy through the Holy Spirit, said, "I praise you, Father, Lord of heaven and earth, because you have hidden these things from the wise and learned, and revealed them to little children. Yes, Father, for this is what you were pleased to do. —LUKE 10:21

MY PROFILE
Shame

ART SUPPLIES FOR SESSION 6

- ☐ 1 large sheet of mixed-media art paper
- ☐ Palette paper or reusable plastic palette
- ☐ 1 set of acrylic paints
- ☐ Large acrylic paintbrush
- ☐ Disposable cup or water container
- ☐ Paper towels or rag for cleanup
- ☐ Black permanent marker
- ☐ A folder, large pad of paper, or firm drawing surface like a large book
- ☐ Pencil

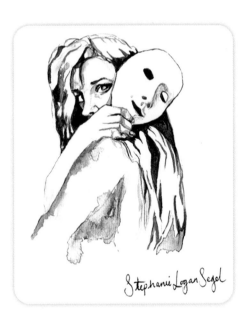

Stephanie Logan Segel

Watch a video from Martha and Stephanie about this week's session at tyndale.life/create_session6.

LOOKING AHEAD

This session explores the topic of shame. As we share and identify our feelings, we will paint a self-portrait to demonstrate how we can replace shameful feelings with positive thoughts and learn to see ourselves as God sees us.

EXAMINE

LOOKING INSIDE

Shame hates having words wrapped around it. If we speak shame, it begins to wither. . . . Language and story bring light to shame and destroy it.
—DR. BRENÉ BROWN

Most of us have things in our past that we are ashamed of, either things we did or things that were done to us—or even our circumstances. If we dwell on these feelings of shame, though, it can change the way we see ourselves, and we may start to believe that we are less than others. But God's Word gives us hope.

Those who look to him are radiant; their faces are never covered with shame.
—PSALM 34:5

Shame doesn't have to be a permanent part of our lives. We can let go of our shame and learn to love ourselves just as Jesus loves us.

LET'S PRAY TOGETHER.

Lord God, please help me to stop holding on to my shame. Focusing on my sources of shame has kept me from seeing who I can become in the growing and healing light of Your love. Help me to walk in confidence to become who You created me to be, reflecting Your image in everything I say and do. In Jesus' name, amen.

PRESENTATION OF FLOWERS

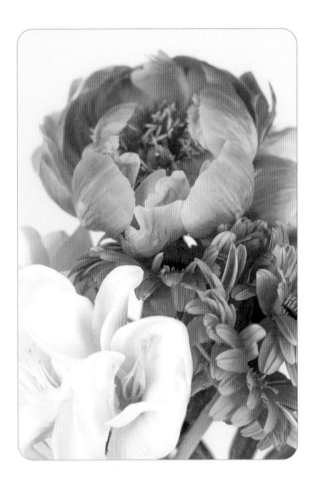

Every time we gather, we offer you a message through some beautiful flowers as a reminder of God's handiwork. Not only do the flowers convey silent meanings, but they simply add beauty and life to any space. We always want you to feel uplifted when we are together.

The PEONY is a popular wedding flower because it means a happy life, happy marriage, good health, and prosperity. But alternately, white peonies can also express feelings of shame or remorse or bashfulness. (One flower can hold many meanings, just like we can feel opposing emotions simultaneously!)

AMARYLLIS is a word that is also a Greek female name meaning "to sparkle," so it makes sense that this stunning flower represents beauty, pride, and determination. As radiantly beautiful and elegant as it is, the amaryllis also represents worth that goes beyond physical beauty.

We're about to discuss shame, so we hope today's flowers remind you that there is often great beauty in revealing what has been hidden. Like the amaryllis, you were made to sparkle as one of God's beautiful creations, and we see your inherent worth and beauty. You are not alone in your feelings of shame or remorse, and you are not stuck there. You are worthy of love and a happy life.

Love,

MARTHA & STEPH

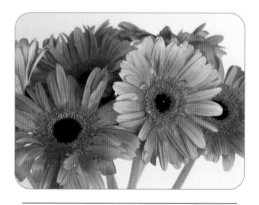

The last flower is a PINK GERBERA DAISY. In the Victorian language of flowers, gerberas represent the simple beauty that often translates to a very happy life.

SHARING OUR EXPERIENCES

What is one thing you really like about yourself?

All too often we dwell on our flaws instead of noticing our beauty, which is kind of like looking at a stunning garden and noticing the one weed growing in the middle of it. Although we think we can view ourselves objectively, our perceptions are often distorted. For instance, we may think we are too heavy, when other people think we look great. People rarely see us the way we think they do or the way we see ourselves. That is partly because of the feelings of shame we carry inside.

The problem with shame is that it isolates us. Feelings of defeat and unworthiness may keep us from connecting with others and make us feel alone. Shame tells us we will never be more than our mistakes, and it eats away at our certainty that we are competent and can do better. But when we stop dwelling on our past mistakes, ignore the lies, and focus on the truth of God's Word, He can remove our shame. This is why we will be discussing our personal sources of shame in today's exercise—bringing them into the light so that we can get rid of their destructive root.

WARMING UP

Have you ever been to a funhouse with those crazy mirrors that make you look wavy or crazy tall or short and wide? Well, it's possible to have people in your life who present a distorted image of who you are, just like those misleading mirrors! We can't always rely on other people's perceptions of ourselves—or our own perceptions!—to be accurate.

To warm up today, grab a partner sitting near you. We're going to create a blind contour portrait, which is essentially a line drawing of your subject. In this case, it will be a portrait of your partner. Focus on the shape of the person's face. Is it round or oval? Are her features angular or soft? How do the corners of her eyes relate to the bridge of her nose? What about her lips—are they thin or full? What about her chin? Pointed or squared off? The reason it's called a _blind_ contour drawing is because you will draw _without_ looking at your paper.

Ask your partner to look straight at you. If you're the one being drawn, feel free to have fun with it—strike a dramatic pose or make a funny face if you wish!

Before you start drawing, here are some tips. Look at your paper and put your finger where you want to start. Remember, this is a "blind" contour, so once you begin drawing, no more looking! Your finger is your reference point—we suggest starting near the top of your paper with the highest point of the face. When you begin to draw, leave your finger on your paper, and with your eyes follow the face shape from the highest point of the forehead down to where the chin meets the neck. As your eyes follow the contours of your partner's face, move the hand holding your pencil. Take your time and draw confidently. Keep your eyes on your subject the whole time—no cheating! Concentrate on the shapes and lines of your partner's face and how they relate to one another. You will have two minutes to complete the drawing.

Now switch and repeat the process with your partner for another two minutes.

This blind contour portrait is a distorted image of you. It's based on reality, but it wasn't intended to be super-accurate—much like a fun house mirror. When you and your partner look at these drawings, they won't look just like either of you, partly because it takes time for someone else to be able to portray an in-depth, accurate image of you. There may be people in your life who perpetuate a distorted view of who you are, based on your past circumstances, false information, superficial reasoning, or their own insecurities. This is why it's so valuable to have a trusted friend in your life to whom you have been able to reveal your true self and who will reflect back an accurate, honest image of you. (Think back to the first session when we talked about being vulnerable and showing our true selves.)

Each of us has had a lifetime to develop an image of ourselves in our heads, but it's often even more distorted than the blind contour drawings you just created. Keep in mind that every portrait is just one of many possible ways to represent you; we're multifaceted persons and cannot be defined by any one thing.

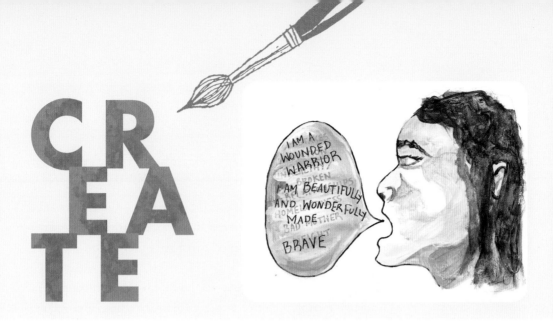

For our art project today, we are going to use markers and acrylic paints to make a self-portrait. We'll share our shame, but by the end of the session we will look at what God says about shame and change our distorted views into a godly view of who we are.

The first step is to lay a large sheet of mixed-media art paper flat on your table in a landscape orientation. With your partner's help, you will create an outline of your own facial profile.

Let's say you're being drawn first. Rest your cheek against the paper, as if taking a nap on the table. If you're right-handed, place your left cheek on the left side of the paper. If you are left-handed, place your right cheek on the right side of the paper. Your nose should be centered on the page. Your partner will make sure you are positioned correctly with your face covering no more than two-thirds of the page. The blank space is where your speech bubble will go. When you're in position, open your mouth as if you are saying "aha." Hold your pencil close to the eraser-end and at a 90-degree angle to the paper. Starting at the top of your forehead, begin to trace your face. The pencil should always be touching your face as well as the paper. Slowly trace along your forehead, over your nose, around your open mouth, over and under your chin, and all the way down to your neck.

Your partner can help as needed, guiding your pencil or adjusting your grip. She can even help you with the actual tracing. You will each have three minutes to complete the profile outline, changing roles each time.

The drawings may or may not look much like you; it's just meant to be a vague outline right now. Touch up the lines if necessary, but you will have the chance to add details later.

Before we move on, let's identify some things that might cause feelings of shame. As people in the group share their responses, one person writes the answers on a board or easel.

You can write down others' responses on the following lines as well as jot down your own responses.

Let's go back to the portraits. On the paper with your profile traced on it, draw a large speech bubble coming out of your mouth, filling the rest of the space on the page. Write inside your speech bubble some of the things you noted that have brought you shame or made you feel less than enough.

Now, we'll prepare to add color. Quickly, let's review what we know about mixing paint colors. All colors can be created by mixing the three primary colors (red, blue, and yellow) in various combinations. Refer to the Color Mixing Chart on page 146 if needed.

Create any light color of your choice by adding a tiny bit of a color to some white paint. Make sure your color is not too dark and the paint is not too thick. Dip your paintbrush back and forth between your water and your new color to thin it out if necessary. Use this color to paint over the words of shame in your speech bubble. Later, we will be writing on top of this color with markers. As you paint, ask God to conquer any and all shame in your life.

Once that's done, you may begin to paint your features. Everyone's skin color is made from the same few colors. Start with brown (either a premixed brown or one you make by blending all three primary colors together) and add some white, depending on how dark or light your skin is. Then look at your skin and think about the underlying colors—does your skin have a yellow, green, or red tint? Add a tiny amount of this color into your brown and add white as needed to lighten it. Take twenty minutes to paint your skin and hair and other features; then we'll set the paintings aside to dry.

As you've been doing this creative exercise, you've heard others acknowledge their shame, and you've identified your own sources of shame. The truth is, we all feel shame to some extent. By being vulnerable with each other and identifying our emotions, we've seen that we often have similar feelings, even if our experiences are different. The question isn't *will* we feel shame, but what do we do with it? Shame is often at the root of feeling unloved or unworthy. There is an overwhelming helplessness and a frantic need to be in control. We worry about what others think about us. Shame lives and grows in darkness. Understanding its sources and talking about our struggles can bring it into the light and release the hold shame has on our lives.

It's wonderful to have a loved one who knows our sources of shame and helps us see the person we can become without those limitations. Now we're going to trust the people in this group to speak encouraging truths to help us see ourselves in a positive light.

Pair up with a partner. As each of you shares what you wrote in your speech bubble, the other person should offer at least two positive comments, words, or Scriptures. Try to put yourself in the shoes of the other person (as you did in session 5 on empathy). Don't judge their actions or what they are feeling—only respond with positive and encouraging statements. For example:

- "I see you regret not being the best parent you could be for your child, but your experience has made you more understanding."

- "I see that you feel shame about your addiction, but your story of rebuilding your life shows the power of God's grace."

- "I understand that you feel shame about your past, but God has redeemed you and shines through your life now."

- "What Satan means for evil, God can use for good."

- "Though we are overwhelmed by our sins, you [the Lord] forgive them all" (Psalm 65:3, NLT).

- "Hope in the LORD; for with the LORD there is unfailing love. His redemption overflows" (Psalm 130:7, NLT).

- "Because of Christ and our faith in him, we can now come boldly and confidently into God's presence" (Ephesians 3:12, NLT).

By sharing your feelings and offering someone else support, you're continuing to practice empathy, and you are laying the groundwork for healing to begin. You have five minutes to interact.

We've talked a lot about how we see ourselves as well as how others see us. Those things matter, but they're often distortions of the whole truth. We are so much more than what people see on the surface. (Think back to the masks in session 1.) God's viewpoint matters the most because He is able to transform and redeem us. His Word over our lives, His promises, and His redemption are the irrefutable absolute truth of who we are and who we can become.

Therefore, there is now no condemnation for those who are in Christ Jesus.
—ROMANS 8:1

In other words, when we step into a life with Christ by believing in Him, our past no longer defines us, and we do not need to carry our shame with us.

A little later in Romans 10:11, the Bible states, "Anyone who believes in him will never be put to shame."

Shame comes from our past and our actions, or from the actions of others (such as in cases of abuse), but now that we are in Christ, we are defined not by these actions but by who God says we are. And He says we are not creatures of shame.

The speech bubble on your drawing should be dry now, but if it is not, carefully dab the wet spots with a paper towel. As you think about these two Bible verses from Romans, write a few positive words inside your speech bubble over the paint covering your words of shame. You may include Scripture, the positive feedback your partner just shared with you, or something you like about yourself. At least one of your words should come from someone else. You will have three minutes.

VIEW AND APPLY

As you look at your finished portrait, you may or may not feel it accurately reflects who you are. But use your imagination and believe that God is the One who drew it . . . because He did. He created the reflection you see in the mirror, which is a beautiful reflection of His own image. He sees you; He loves you; He has a unique plan just for you. And He knows who He has created you to be.

He did not create you to dwell in a place of shame but will transform your sorrows into joys. He promises

> to give unto them beauty for ashes, the oil of joy for mourning, the garment of praise for the spirit of heaviness; that they might be called trees of righteousness, the planting of the LORD, that he might be glorified. —ISAIAH 61:3, KJV

LET'S PRAY.

Lord God, thank You for helping me to see that condemnation is not from You. Help me no longer see myself in a distorted way but rather know the truth of how You see me. Thank You that I don't have to live my life under the weight of my past mistakes or hurts. I choose to trust what Your Word says about me: that I am loved and worthy, a precious child in Your eyes. In Jesus' name, amen.

REFLECT AND REMEMBER

Here's what past participants have said about their experiences. Read through their words, and then add your own brief reflections to help you remember what the session was all about.

WHAT PEOPLE SAID THEY LIKED BEST ABOUT SESSION 6

SHAME

- "It's art, growth, and fun, all mixed together."
- "It's not like a class; it's a therapy session."
- "The projects made me open up and share and cry. And laugh. I felt so happy at the end even though I had cried."
- "It's mind-blowing to realize my worth isn't based on what I've done wrong, but on how God sees me."

WHAT I SAY

REINFORCE

This completely optional exercise is designed to help you retain what you just learned. If it is fun for you to do so, you may complete this during the coming days, but do not feel any pressure. You are in control and can do as much or as little as you like.

Shame convinces us that we are not worthy of love and kindness, but God has declared that we are valuable—not because of anything we did, but because of His fathomless grace and mercy. It's easy to forget that when we're confronted with our mistakes or people judge us based on our past. So we need to train our minds to remember who God says we are.

Buy a small journal or make a booklet by folding several pieces of paper in half and stapling them together. On the cover, write your name in big letters. Underneath that, in small letters, write the subtitle "Through the Eyes of God."

At the top of each page, write down a Bible verse that talks about who you are in God's eyes. Below that, if you want, journal your feelings or write a short prayer related to the verse.

Not sure how to find the Scriptures? Your Bible may have a concordance in the back with verses listed by topic. You may also search online for Bible verses about self-esteem, identity, or beauty. If you're feeling really creative, think about how each verse makes you feel and sketch that beside the words. Here are a handful of verses to help you get started:

> See what kind of love the Father has given to us, that we should be called children of God; and so we are. —1 JOHN 3:1, ESV
>
> You are altogether beautiful, my love; there is no flaw in you. —SONG OF SOLOMON 4:7, ESV
>
> Do you not know that your body is a temple of the Holy Spirit within you, whom you have from God? You are not your own. —1 CORINTHIANS 6:19, ESV
>
> Why, even the hairs of your head are all numbered. Fear not; you are of more value than many sparrows. —LUKE 12:7, ESV
>
> God created man in his own image, in the image of God he created him; male and female he created them. —GENESIS 1:27, ESV
>
> Our citizenship is in heaven, and from it we await a Savior, the Lord Jesus Christ. —PHILIPPIANS 3:20, ESV

SESSION 7

DOODLES
Self-Doubt

ART SUPPLIES FOR SESSION 7

- ☐ 1 sheet of mixed-media art paper
- ☐ Palette paper or reusable plastic palette
- ☐ Colored pencils
- ☐ Pencil sharpener
- ☐ White acrylic paint

- ☐ 1 large acrylic paintbrush
- ☐ Disposable cup or water container
- ☐ Paper towels or rag for cleanup
- ☐ Black permanent marker
- ☐ Pencil

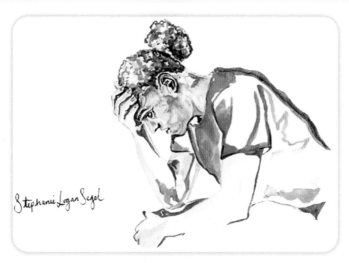

Stephanie Logan Segel

Watch a video from Martha and Stephanie about this week's session at tyndale.life/create_session7.

LOOKING AHEAD

Today, through art and discussion, we are going to explore the topic of self-doubt. Each of us will create a doodle art drawing with words of truth about ourselves, write a letter to our inner critic, and identify messages that cause self-doubt. This will help us replace self-doubts with God's truth of who we really are.

EXAMINE

LOOKING INSIDE

The worst enemy to creativity is self-doubt. —SYLVIA PLATH

Who has ever doubted themselves? Don't even bother to raise your hands—we've all been there. Sometimes several times a day!

Our verses for today are 2 Corinthians 12:9-10. In verse 8, Paul relates how he prayed for healing from an affliction three different times (see page 8 of session 1). Each time, God gave Paul the same response:

My grace is sufficient for you, for my power is made perfect in weakness.
—2 CORINTHIANS 12:9, ESV

Finally, Paul realized that God would demonstrate His unlimited power through Paul's limitations, causing the apostle to rejoice:

Therefore, I will boast all the more gladly of my weaknesses, so that the power of Christ may rest upon me. For the sake of Christ, then, I am content with weaknesses, insults, hardships, persecutions, and calamities. For when I am weak, then I am strong. —2 CORINTHIANS 12:9-10, ESV

Lord God, Your mercy and grace are so amazing, providing the power to heal me and change me. Please give me the strength to recognize my weaknesses so I can grow stronger and walk forward in a new direction. Give me courage to allow You to use my weaknesses, just as You did with Paul, in a way that helps others and points them to You. In Jesus' name, amen.

PRESENTATION OF FLOWERS

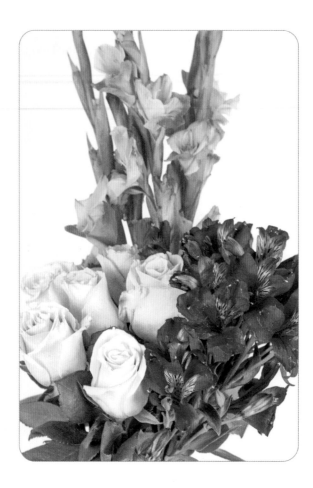

"A flower is not a flower alone; a thousand thoughts invest it," wrote Mandy Kirkby. Across time and cultures, flowers have offered new insights and messages without needing to use words. Even if you don't know the layers of meanings, the flowers have an inherent beauty—as do each of you.

The GLADIOLUS stands tall and means strength and moral character, sincerity, and faithfulness. It tells us to never give up.

To represent grace, gratitude, and joy, we have the gentle PINK ROSE.

The last flower is ALSTROEMERIA, which signifies devotion among family and friends as they help you overcome the trials of everyday life to follow your dreams and achieve your goals.

Our wish for you today, expressed through the meanings of these flowers, is this: We hope that you will be able to stand tall, knowing that your life is characterized by moral character and faithfulness. We encourage you to develop a trusted network of friends and family who will support you, just as you support them, in the journey of working toward your dreams and goals. As you grow and change, may God's grace abound and may you respond to it with gratitude and joy.

Love,
MARTHA & STEPH

SHARING OUR EXPERIENCES

Today we are going to have a conversation with our "inner critic," that inner voice that is always hardest on us. The one that says we're not good enough, creative enough, smart enough, strong enough, or worthy enough. It keeps us from venturing outside our comfort zones. It prevents us from taking leaps of faith and making positive changes by convincing us we will fail.

Some of us aren't even aware of the power this voice has over our lives. Others of us recognize how controlling this inner critic is and go out of our way to avoid confronting it. The good news is, we don't have to be afraid of it; it can be silenced. But the first step to overcoming it and turning self-doubt into self-confidence is to identify it. Since this voice is devious and often deeply ingrained in our thinking, that may be harder than it sounds.

We're going to allow our inner critic to speak now or forever hold its peace. What is one thing your inner critic is saying to you? As you share these things out loud with the whole group and they add their own responses, write down the ones that resonate with you. (For instance, "I'm not smart enough," "I am fat," "I am not creative," or "I am not a good mom.")

All people experience self-doubt. As you can see, the messages we hear from our inner critic can be discouraging, but we're here today to encourage you: You don't have to be a victim of self-doubt, and you can take steps to tame the voice that discourages you. When we embrace God's truth, it becomes easier to dismiss those lies and hold less tightly to our doubts. With each step forward, the doubt recedes more and more into the past.

WARMING UP

Before taming your inner critic, you need to give it a voice and bring your self-doubt into the light.

On one side of your mixed-media paper, write a letter to your inner critic with your marker. What would you really like to say to it? "I'm not going to listen to you anymore"? Maybe "I don't believe you" or "You are telling me lies." You will have five minutes to write your letter. Write large enough so your letter fills the page.

You will have a chance to talk about what you wrote later, but right now we are going to begin the process of creating something beautiful to replace that negative voice. Start by adding water to a little bit of white paint on your palette until it runs thin. This mixture— called a wash—should partly obscure the letter you wrote to yourself, while still enabling the writing to lightly show through. Keep the layer of paint thin enough to dry quickly and completely because you will need to draw on top of it in the next step. Spend about five minutes painting your wash.

CREATE

Would anyone like to share what you wrote to your inner critic and how it felt to write it?

The Sylvia Plath quote, "The worst enemy to creativity is self-doubt," holds true for many of us. So many people have their creativity stifled early in life when a teacher or parent says a drawing wasn't done right, and they grow up believing they can't make art. They'd rather not try than to fail. We're so glad you're being vulnerable and working through this series with us because we believe everyone can make art!

Earlier you gave voice to your inner critic; this time, do your best to silence it. Even if your inner critic tells you the opposite, what are some positive truths about you? Write down some things that you know to be true about you (for example, "I'm a loyal friend," "I am capable," "I am smart enough"), and don't forget to include what God says about you, such as "I am fearfully and wonderfully made" (Psalm 139:14) or "I am God's masterpiece" (see Ephesians 2:10, NLT).

There's such a difference between what our inner critics tell us and what other people—and God—say about us. When those things don't line up, we can safely identify our self-doubts as lies.

Now that we've shed light on our negative inner voice and recognized some positive truths about ourselves, we're going to turn our letters to our inner critics into something beautiful that represents who we are according to God's truth. To do that, we are going to have fun creating doodle art, using markers and colored pencils.

Check your letter and see if the white paint wash is fully dry. If not, use a clean paper towel to dab any wet spots.

Look at the following sample of doodle artwork to inspire the next step.

Now use your marker to doodle on top of your letter. Fill the page with circles, squiggles, various geometric shapes—whatever you want. Don't put too much thought into what you are drawing. You are not trying to make any specific design. The key is to keep your marker moving. Try to make sure your lines don't touch or cross over each other. You can draw shapes inside of other shapes. If you get stuck, look around the room, find an interestingly shaped object, squint your eyes, and roughly create an outline of it.

You will have five minutes to complete your doodle art.

Set your marker aside and take out your colored pencils. Yay! We're going to color. Coloring is a soothing activity shown to decrease stress. It draws the focus away from us and into the present moment.

Take a moment to select your colored pencils, being intentional about the colors you use. As you know well by now, colors represent different emotions. The Color Emotions Chart on page 145 may help you select colors to use in your drawing. Think about what you are feeling, what you think of your inner critic, and how you feel when you succeed despite your inner critic telling you that you won't. Use those emotions to determine your colors. Refer to page 143 for the List of Emotions if you need ideas.

Once you finish coloring, choose some of the positive words or phrases about yourself that you wrote earlier, or others you may think of now, and write at least three words or phrases inside or around the shapes in your doodle art. You will have fifteen minutes to both color your doodle art shapes and add these positive, encouraging words and phrases to your artwork.

VIEW AND APPLY

Who wants to share?

Today you have taken steps to tame your inner critic by replacing the judgmental voice with positive thoughts in a fun and creative way. Powerful, right?

There's an even more powerful weapon we have when we are battling our inner critics, and that is the Word of God. In the following verse, God encourages us not to follow what the world says we should do and give in to self-doubt.

> Do not conform to the pattern of this world, but be transformed by the renewing of your mind. Then you will be able to test and approve what God's will is—his good, pleasing and perfect will. —ROMANS 12:2

God says we should not conform to the pattern of this world. The art you just created, which is a product of your own work and God's Word, forms a beautiful pattern for a beautiful life.

LET'S CLOSE IN PRAYER:

Lord God, thank You for Your perfect will working in and through my life. Help me to recognize self-doubt when it tries to creep into my thoughts. Give me the strength to paint over these self-doubts, whether literally as I did today or only in my mind. Please, by Your Spirit, transform those negative thoughts into positive encouragement with Your tender mercies and gentle grace. In Jesus' name, amen.

REFLECT AND REMEMBER

Here's what past participants have said about their experiences. Read through their words, and then add your own brief reflections to help you remember what the session was all about.

WHAT PEOPLE SAID THEY LIKED BEST ABOUT SESSION 7

SELF-DOUBT

- "Turning bad thoughts into good ones through art."
- "I loved it because now I have a little confidence in myself."
- "Doodling helped me focus my thoughts and believe I'm capable of more than I thought."
- "I didn't realize how self-doubt was controlling my thoughts. This helped me overcome such a current and relevant struggle."

WHAT I SAY

REINFORCE

If you've enjoyed this doodling exercise, this optional extra activity should be right up your alley. If it is fun for you to do so, you may complete this during the coming days, but do not feel any pressure. You are in control and can do as much or as little as you like.

One interesting method of prayer is prayer doodling, in which you offer your doodles to God as your prayer. Start with a blank sheet of paper and write something in the center of the page to get you started, such as *God*, a name or aspect of God (such as "the Alpha and Omega"), or a favorite Scripture.

As you pray, let your marker go to work. You might doodle names or initials of those for whom you are praying, or symbols like hearts and arrows to connect people. You may create elaborate borders around separate thoughts or group people in lists. Maybe you'll want to doodle a broken heart next to people who are grieving and a smiley face by those who are celebrating something. You may want to draw one large shape or border around them all to remind yourself that we are all connected through God's love or use lines and shapes to map out the path of your stream-of-consciousness thoughts. Keep an open mind: Wherever your marker takes you, follow it. Just be sure to mentally offer these thoughts and doodles to God as your prayer. You may color them in if you wish, but it's not necessary.

Some Bible verses that reinforce this lesson and may be a good starting point for your prayers are the following:

> When they call on me, I will answer; I will be with them in trouble. I will rescue and honor them. —PSALM 91:15, NLT
>
> I can do everything through Christ, who gives me strength. —PHILIPPIANS 4:13, NLT
>
> The Spirit God gave us does not make us timid, but gives us power, love and self-discipline. —2 TIMOTHY 1:7
>
> If any of you lacks wisdom, you should ask God, who gives generously to all without finding fault, and it will be given to you —JAMES 1:5
>
> See what great love the Father has lavished on us, that we should be called children of God! And that is what we are! —1 JOHN 3:1

SESSION 8

MY ROOTS
Pride

ART SUPPLIES FOR SESSION 8

- ☐ 1 sheet of mixed-media art paper
- ☐ Palette paper or reusable plastic palette
- ☐ 1 set of acrylic paints
- ☐ Acrylic paintbrushes (sizes 9–12 and one that is smaller)
- ☐ Disposable cup or water container
- ☐ Paper towels or rag for cleanup
- ☐ Black permanent marker
- ☐ Pencil

 Watch a video from Martha and Stephanie about this week's session at tyndale.life/create_session8.

LOOKING AHEAD

During today's session, we will identify areas in our lives where we struggle with being prideful and list words and actions that describe humility. We will create a tree of life painting to reflect the transformation from pride to humility.

LOOKING INSIDE

> This is true humility: not thinking less of ourselves but thinking of ourselves less.
> —RICK WARREN

Pride and humility are two sides of the same coin. The Bible talks about pride in Proverbs:

> Pride leads to disgrace, but with humility comes wisdom. —PROVERBS 11:2, NLT

In the New Testament, the apostle James tells us the reward of humility:

> Humble yourselves before the LORD, and he will lift you up in honor.
> —JAMES 4:10, NLT

Most of us have experienced times in our lives when we found it hard to admit we made a choice that caused ourselves or someone else pain. Our pride may have kept us from confessing the truth because we want to be seen in a positive way—or we may simply have felt stubborn in the moment. We may be able to hide this from others, but God lovingly sees everything in our hearts and knows the truths we try to hide. Today, we will identify ways to help us overcome our pride through humility and love.

LET'S PRAY.

Lord God, I want a teachable heart. Give me the ability to look honestly at myself and identify harmful forms of pride. I ask for Your gentleness and grace to accept the truths of my life. Help me live humbly, so that everything I say and do will become a reflection of Your character and love. In Jesus' name, amen.

PRESENTATION OF FLOWERS

Aspiring writers are instructed to "show, not tell," especially when they are describing a person's emotions. It's something Stephanie Skeem captures in her quote "Flowers don't tell, they show." Let's see what today's flowers both tell us and show us about ourselves!

The tall and proud AMARYLLIS, with its upright, strong stalks, represents splendid beauty, worth that goes beyond surface beauty, and pride.

We also have an ORANGE LILY, meaning confidence—which, taken to the extreme, may take the form of pride.

Our message for you is to be able to shed all the negative emotions that weigh you down so you can stand straight and tall, knowing you are beautiful inside and out. May you have the confidence to believe that you are worthy of love and capable of change. Let that confidence be balanced with a sweet and humble spirit that admires others and their accomplishments and encourages those around you.

Love,

MARTHA & STEPH

Our third bloom is the elegant PURPLE TULIP, which represents admiration for one's accomplishments.

SHARING OUR EXPERIENCES

Before we begin, take a minute to reflect on how you would answer this question.

Are you always willing to admit when you do something wrong?

Why do you think it's so tempting to deflect or pass the blame? It likely has something to do with not wanting to look bad or be judged. Our underlying pride motivates us to go to great lengths to create an image of ourselves that doesn't match reality, or we lie to hide the truth of our actions.

It's okay to feel good when you have accomplished something, such as losing weight and keeping it off, overcoming an addiction, getting a job or promotion, or even finally cleaning out that closet you've avoided for two years! It's also fine to be proud of other people's accomplishments, such as those of your children or family members. But a healthy type of pride becomes *un*healthy when it is arrogant or self-righteous—when it devolves into bragging, stubbornness, refusing to admit you're wrong, not accepting help, or putting others down.

Pride means we always put ourselves front and center, connecting every experience and conversation back to us. At the core of pride is selfishness and self-worship. It may look different in different people, and some people are better at concealing it from others, but pride is anything that causes you to think of yourself above others.

Humility is the opposite of pride. As today's quote says, humility is "not thinking less of outselves but thinking of ourselves *less*." Being humble isn't being a doormat, and it doesn't mean you put yourself down or you don't stand up for yourself. When you talk with a humble person, you feel validated—that they are interested in you—because the conversation isn't all about them. A humble heart isn't consumed with things like status, image, conceit, or wealth. Instead, humility gives birth to positive qualities like compassion, patience, and love.

A humble heart is free.

An example of pride and humility in action is illustrated in the story of the Pharisee and the tax collector.

Two men went up to the temple to pray, one a Pharisee and the other a tax collector. The Pharisee stood by himself and prayed: "God, I thank you that I am not like other people—robbers, evildoers, adulterers—or even like this tax collector. I fast twice a week and give a tenth of all I get."

But the tax collector stood at a distance. He would not even look up to heaven, but beat his breast and said, "God, have mercy on me, a sinner."
—LUKE 18:10-13

In this Bible story, who do you think shows the most humility, the Pharisee or the tax collector? Why?

Pharisees were the experts on Jewish law. Because of this knowledge, they acted very important and were puffed up with pride. On the other hand, tax collectors were considered crooks, and they were not well respected. As the Bible shows, Christ takes what people believe to be true and turns it upside down. According to Jesus, people who are considered *less than* are the ones who actually demonstrate the most godly characteristics.

What words would you use to define pride? In the space below, write the group's responses on the left side, leaving the right side blank. We'll use that side later.

WARMING UP

Today we are going to create a tree of life, using markers and paint to help us identify and let go of our pride. We will then let humility take root and trust God to continue to help it grow and flourish in us. Today's warm-up will become part of the main painting.

Are you familiar with the banyan tree? Here is what it looks like.

Banyan trees grow so large because they drop aerial roots, or "false trunks," from their branches, which can grow as thick as an oak tree trunk. These roots may look impressive, but they don't go deep—they are grounded in a shallow foundation. Also, banyan trees take over whatever they grow on top of, strangling the original host tree to death by enveloping it, often leaving a hollow inner core. What looks imposing and strong may be rotted out and empty inside.

Using the photo as your example, take your pencil and draw the outline of a tree with lots of thick roots and branches on your paper. You may want to overlap the branches as shown in the photo and even draw some roots trailing down from the branches to the ground. You have five minutes to fill your paper completely with your drawing.

Now, inside the roots and branches, use your black marker to write down some places in your life in which you struggle with pride. Refer to the words offered by the group and also think about the ways in which prideful feelings and behaviors have been a part of your life. You will have five minutes to write.

CREATE

We all have areas in our lives and personalities in which unhealthy behavior takes root, but those don't have to become defining characteristics of who we are.

It's time to finish your tree drawing with acrylic paints. With black paint, fill in the roots and branches, being sure the paint completely blocks out your words of pride. Add just enough paint to cover the words completely, but not so much that it takes a long time to dry. While you paint these bold black lines, ask God to help you dig up your unhealthy pride and plant humility in its place.

You will have five minutes to paint your roots and branches. When you're finished, wash your brush thoroughly to remove the black paint, then replace the water in your cup with clean water.

You've already learned about how to mix the three primary colors (red, blue, and yellow) to create secondary colors. On a color wheel, these secondary colors are placed in between the primary colors in a circle, resembling the Analogous Color Scheme pictured below. The term *analogous colors* refers to any one wedge of the color wheel—a group of related colors that are near each other (for example: red and purple or green and yellow).

The next step is to add color in the open spaces between and around the roots and branches. Using what you know about colors and what they mean—refer to page 145 if you need to refresh your memory—select at least two analogous colors to use in each open area. As you apply the different colors, gently blend them together so the color morphs from one into another. This will make your sky look similar to a sunset. This beautiful process represents the way pride can transform into humility. If your black paint is still wet, be careful not to touch it with your brush or it will smear.

As always, you may add water to make your paint thinner, or add white to lighten a color or a tiny bit of black to make it darker. It only takes a small amount of each color, so mix carefully.

While the paintings dry, let's talk about the consequences of pride. Whether we intend it or not, our pride can cause us to hurt people we love the most. Imagine you did something that hurt a dear friend. Pride might make you blame someone else for your own actions, or it might cause you to refuse to apologize when the opportunity presents itself. This can lead to broken and fractured relationships. Unless we take a good look at ourselves, we may not even know how much pride has taken root in our lives.

But humility and love can overcome pride. Think about what it means to be humble and how humility demonstrates love. What words would you use to describe someone who is humble? Examples might include being modest, putting others before yourself, and so on. Write the responses on the right-hand side of the paper where you earlier wrote prideful words.

When your painting is dry, take a small brush and use white paint to write at least two words that represent humility in the branches on top of the black paint. Your words may come from a number of places—you may ask the person next to you for a word that describes you, use words written on the board, or think about someone you admire and how you would describe them. You might even want to think about what you've learned from previous sessions. Many humble people display characteristics such as vulnerability, empathy, and forgiveness. You will have five minutes to complete.

VIEW AND APPLY

The Bible says,

> Don't be selfish; don't try to impress others. Be humble, thinking of others as better than yourselves. Don't look out only for your own interests, but take an interest in others, too. —PHILIPPIANS 2:3-4, NLT

When we think too highly of ourselves, we can get puffed up and take over everything around us, much like the banyan tree. We may appear to be strong, but we have a shallow foundation and may feel hollow inside.

Humility helps us remember that we are not more important than those around us. Genuine interest in the concerns of others connects us, adding support and stability to the relationship and strengthening it. Practicing humility allows us to create a community that is defined by love. As Jennifer E. Jones said, "Love is the absence of pride. It makes you drop all of your man-made defenses and allow God to shine through your weaknesses."

Your tree of life illustrates how humility can transform pride into something better, something beautiful.

Shall we ask God to begin that transformation in us now?

LET'S PRAY.

Lord God, I'm so thankful that You know everything about me—my thoughts, my words, my actions, and my heart—and that You love me anyway. Thank You for Your forgiveness. Search me and open my eyes to anything prideful within me, so that I can be healed and made whole. You are the God of the universe, yet You humbled Yourself and came to earth to experience what we go through. You care about the things that matter to me. Let me strive to genuinely show this kind of respect to others. In Jesus' name, amen.

REFLECT AND REMEMBER

Here's what past participants have said about their experiences. Read through their words, and then add your own brief reflections to help you remember what the session was all about.

PRIDE

- "The tree was very creative and easy."
- "I always thought humility was about being a doormat, but it's really about caring about others."
- "This showed me how pride takes root and takes over everything, but it can be overcome with humility."

WHAT I SAY

REINFORCE

This completely optional exercise is designed to help you retain what you just learned. If it is fun for you to do so, you may complete this during the coming days, but do not feel any pressure. You are in control and can do as much or as little as you like. Note: This one involves construction paper and scissors and may make you feel like a child again. (Feel free to recruit any children in the household to do this with you!)

In the natural world, peacocks are a great representation of pride. If you've ever watched a male peacock strut, you know what we mean. He gets all the glory as he shows off his brightly colored blue-and-green feathers. The female peahen's feathers are less flashy.

Often, prideful people are the ones who take center stage in our lives, while the ones who are humble blend into the background. One of the most loving things you can do for someone is pray for them, so this activity is designed to help you pray for the people in your life who are often overlooked.

Take a look at the peacock feather here to get an idea of its shape, then sketch several large feathers onto sheets of blue and green construction paper. Cut them out and create feathered edges with your scissors. If you want to make them more realistic, you may paint the distinctive eye-like spot on each feather, but it's not necessary.

When your feathers are done, close your eyes and ask God to bring to mind people in your life who don't get much attention, whether because they are overlooked or because they are humble. Think about the people in your life who make you feel seen, valued, and known. Write their names along the spine of each feather as you pray for each person. Place the feathers in a vase or gather them in a bowl and whenever you see them, let them be a reminder to pray.

STILL LIFE: FLOWERS
Accountability

ART SUPPLIES FOR SESSION 9

- ☐ 1 sheet of mixed-media art paper
- ☐ Palette paper or reusable plastic palette
- ☐ 1 set of acrylic paints
- ☐ 1 set of watercolor paints
- ☐ Large acrylic paintbrush
- ☐ Small paintbrushes
- ☐ Disposable cup or water container
- ☐ Paper towels or rag for cleanup
- ☐ Pencil

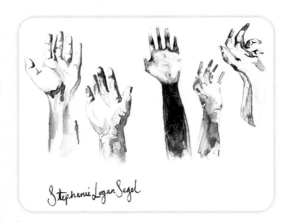

Stephanie Logan Segel

Prep just before the beginning of the session

Since today's project is a still life of a flower, please ensure there are at least as many flowers as participants. Even if you typically only use pictures for the Presentation of Flowers, it is important to have actual physical flowers (fresh or artificial) for this session. Each type of flower should be a different color, and none of them should be white. Ideally, have a few extras so that people can choose the one that is the most meaningful to them.

Arrange the flowers for today's Presentation of Flowers in a vase and place them on a table or chair at the front of the room where the participants can see them (refer to note on Presentation of Flowers in the Facilitator's Guide on page 139).

Watch a video from Martha and Stephanie about this week's session at tyndale.life/create_session9.

LOOKING AHEAD

Today, through art and discussion, we are going to explore the topic of accountability. We will create a beautiful still-life painting of a flower, using watercolors and acrylics while identifying the emotions related to a personal experience with accountability.

EXAMINE

LOOKING INSIDE

> The creative act began with God creating the universe in which we live. The next creative act begins when we allow God to recreate the universe within us.
> —ERWIN MCMANUS

Today's verse says,

> Do to others whatever you would like them to do to you. This is the essence of all that is taught in the law and the prophets. —MATTHEW 7:12, NLT

This is called the Golden Rule—treating others the way you want to be treated. One way you can do this is by taking ownership of situations you're involved in, both good and bad. As you practice what you've already learned in *Create: New Beginnings*, you're well on your way to achieving personal accountability.

Accountability means being honest with ourselves and God about our situations and emotions. It involves being vulnerable and sharing our struggles, as well as letting go of the pride that may keep us from admitting our mistakes and taking responsibility when we are in the wrong. With God's help, we can find the courage to admit our failures, while humbly embracing our strengths. All of this helps us have healthier relationships and love ourselves and others in a more authentic way.

LET'S PRAY TOGETHER.

Lord God, I pray that You will transform me from the inside out. Help me to see clearly my role in situations and take responsibility for my actions. Help me love others as I am loved by You, and help me love myself with compassion. Teach me to hold myself accountable and guide me in healing broken relationships. In Jesus' name, amen.

SHARING OUR EXPERIENCES

You may be expecting the presentation of flowers at this point, but we are changing the order of things in this session. We'll get to the flowers in a few minutes. Speaking of flowers, though, what is your favorite flower? Is it tied to a specific memory?

Write your thoughts here.

--

--

--

--

--

Now let's continue to define accountability and how we can implement it effectively in our lives. Society has established certain standards for behavior that tell us what to expect from others, whether it's how children play with each other on the playground or how friends should treat us. A trusted friend can help us do better by knowing our desires and encouraging us to follow through and make healthy choices. That is a valuable type of accountability. But today's session is not about holding someone else accountable; it's about holding ourselves accountable.

It is easy to ignore our own failures; after all, it's hard work to change. Sometimes it's easier to blame others or dismiss our own responsibility in a specific situation. Other times, we mask our feelings (much like we discussed in the first session) and pretend we're all okay. When we're personally accountable, we take ownership of situations we're involved in and accept responsibility for the consequences, both good and bad. It's about accepting the reality of our feelings, circumstances, and actions. Being accountable is doing our best to make things right when we have hurt someone else; it's about choosing to do the right thing, no matter how hard and no matter who is watching.

Some actions, quite simply, have consequences—broken laws carry penalties. Broken trust damages relationships. Not taking care of our health may lead to illness. Allowing God into our journey toward accountability doesn't miraculously free us from the natural consequences of our actions, but God can free us from the shame, pride, and other emotions that weigh us down.

Now let's start an art project that will help us take a deeper look at personal accountability.

WARMING UP

For our warm-up today, we're going to make the background for your still-life painting. To start, look at the Color Emotions Chart on page 145 to refresh your memory about which emotions are represented by each color. You will recall that colors and emotions are directly linked to each other and that each color affects us differently.

One of the most beautiful aspects of watercolor painting is how the colors run and bleed into each other. This can happen only when the paints are applied to a wet part of the paper. You may recall that we used this technique, called a watercolor bleed, in session 4 on emotions. Before you begin painting, use a large brush to wet the page all over with clean water. As you place paint onto the wet page, your colors and shapes will spread out and blend into each other.

When painting with watercolors, you will want to use a lot of water to help the paint go further. Once you finish with one color, dunk your paintbrush several times into your water cup and swish it around to remove the pigment before you begin with a new color. Sometimes it's helpful to wipe the brush on a folded paper towel to help remove excess color.

Now it's time to start on your background.

Can you remember a time when you did not hold yourself accountable? You may have blamed someone else for something you did, or deflected blame for something you should have done but didn't. Maybe there were consequences like a broken relationship, a lost job, or even breaking the law. Or perhaps the results were more internal—feelings and emotions like shame, or dishonesty, or disappointment in yourself. As you mentally relive this experience, select colors that connect to the emotions you felt at the time. Use the watercolor paints to express the actions you took or should have taken, whether or not you held yourself accountable in this instance. You may express these feelings on the page abstractly using lines, colors, and shapes. You have five minutes to paint the background of your painting. When you are finished, set it aside to dry.

How did you feel when you were painting?

PRESENTATION OF FLOWERS

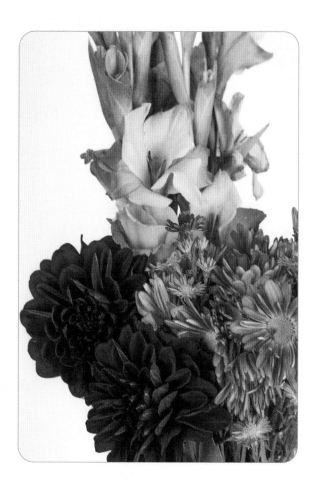

Now let's focus on today's flowers. As you know, every session we share an intentional message to you through the meanings of three different flowers. We hope you'll pay special attention today, though, because you are going to be painting one of these flowers. As we discuss each flower's meaning and then pass them around so you can look at them more closely and touch them, please think about which one best reflects how you feel.

Our first flower is the regal GLADIOLUS, which we've used twice before because we love its meanings. Known for its tall spikes and large, colorful blooms, the gladiolus tells us to never give up. It also represents the ideas of strength of character, generosity, integrity, and faithfulness—all of which are necessary for personal accountability.

We also included the DAHLIA, which symbolizes dignity and grace under pressure. It represents drawing upon your inner strength and making a positive life change.

Today we'd like to turn our flower message into something even deeper, so let's pray together.

Heavenly Father, help us to not give up on this journey to become more like Christ as we identify and recognize our emotions and take responsibility for our actions. Give us the strength of character and integrity to faithfully respond to Your challenges by trusting in Your leading. When we are under pressure, grant us the strength necessary to respond with honesty and grace. We know that You are cheering us on as we work toward positive life changes. In Jesus' name we pray, amen.

The last flower is a CHRYSANTHEMUM, which represents optimism, rest, and longevity. As with most of our flowers, the bloom's color conveys a specific meaning, and some chrysanthemums convey the ideas of loyalty and honesty, which are critical for an accountability relationship.

CREATE

Each of you may now select a flower out of the vase to use as the subject of your painting. Again, think about the symbolism of each flower before you choose one.

Place your flower in front of you in any position you like. It is best to either lay it at the top of your table above your paper or off to the side where you have a good view. We're going to be creating a still life painting, which simply means you will be painting a static image, always viewing it from the same angle. Once you begin, do not move the flower at all.

Think about the situation on which you based your background painting and how it might have looked if you had taken responsibility.

When you paint your flower, you will be covering this memory with what we will call an "accountability flower." As you contemplate that, use a small paintbrush and paint a white outline of your flower on top of your background painting. You're not attempting to paint the actual flower yet; instead, paint only the shape of the "negative space," the space around the outside of the entire flower.

It may look abstract and nothing like a flower at this stage—that's okay. Your finished painting will include the details within the stem, leaves, and petals, but do not worry about those yet. This is merely a contour of the outer shape of the flower. It does not need to be perfect and should be eyeballed, not traced. See the example. You will have five minutes to paint the shape of your flower.

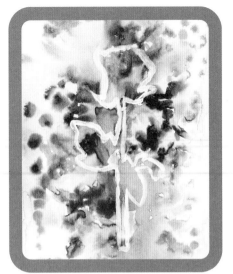

Once the outline is complete, use your white paint and a paintbrush to fill in the inside of the shape. You will now have a white silhouette surrounded by your colorful watercolor background. (See the following example.) Don't apply thick globs of paint but keep the paint as smooth as possible so it will dry faster.

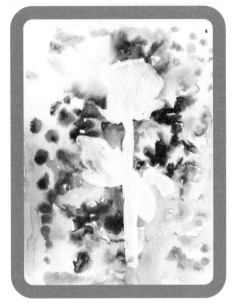

While we're waiting for the paint to dry, who would like to tell us what flower you picked and why you selected it?

Write your own answer below.

When your paint is dry, use the silhouette as a guide to fill in the details of the flowers, or the "positive space." You can paint the leaves, create individual petals, define the stem, and add shadows. Use any of your acrylic paints and any size paintbrush, mixing colors as needed to represent the colors in your actual flower. At this point, you're all pros at mixing colors, but here are just a few quick reminders. You may use the Color Mixing Chart on page 146 to help you mix colors. Don't forget that you may add white or a tiny bit of black to lighten or darken the colors, and adding water will make the paints thinner. Be sure to use your cup of water and paper towels to clean one color off the brush before you begin using another.

You have fifteen minutes to complete your paintings.

VIEW AND APPLY

We would love to hear about your personal experiences with accountability and how they influenced the artwork you created. Is anyone willing to share with us?

When you take your painting home, display it in a prominent spot where you can see it as a reminder to hold yourself accountable—to do the right things out of love for others and for yourself. Accountability isn't only about taking responsibility for wrongdoing, but also accepting and acknowledging good things. In that spirit, give yourself credit for what you did today—you turned a negative experience into something beautiful that you can carry with you into the future.

Let's wrap up with another encouraging verse. The apostle Paul wrote,

> Brothers and sisters, I know that I still have a long way to go. But there is one thing I do: I forget what is in the past and try as hard as I can to reach the goal before me. —PHILIPPIANS 3:13, ERV

We always have room to do better. Growth is a continual process in our spiritual life. Reflecting on what happened to us in the past can help us understand where we are in the present and how to put the past behind us. Through it all, though, God is with us. He longs to "recreate the universe within us," as the quote at the start of this session said. God is able to help us reframe our existence of what is and what was. His grace covers us, and this gives us the freedom to hold ourselves accountable and the ability to move forward in confidence.

LET'S TURN TO GOD IN PRAYER.

Lord God, thank You for Your faithfulness in loving me even as You show me ways to be better. Thank You for Your grace. Thank You for planting within me the desire to hold myself to higher standards and become more like You. Where I lack understanding, I ask for Your wisdom. Where I need to repent or change, reveal that to me with gentleness and mercy. Give me a kind and teachable heart and help me to offer others all that I hope they will offer to me. In Jesus' name, amen.

REFLECT AND REMEMBER

Here's what past participants have said about their experiences. Read through their words, and then add your own brief reflections to help you remember what the session was all about.

ACCOUNTABILITY

- "How we all came together in unison to paint out our recovery."
- "Painting the flowers allowed me to tap into an inner peace, which was so greatly needed."
- "I liked learning about the meanings the different flowers had. The flower art project was relaxing and therapeutic and brought out talents that maybe nobody knew they had."
- "It was such a beautiful experience. I really enjoyed this. Thank you. I always thought, *I'm not an artist*, but today I found out I am."
- "I found this class relaxing, mind-opening, and gracious. Now I can let go and move on."
- "I really enjoyed the activity and the learning that went along with it. I always thought paintings had to be exact but after this session, I no longer think that way."

WHAT I SAY

REINFORCE

This completely optional exercise is designed to help you retain what you just learned. If it is fun for you to do so, you may complete this during the coming days, but do not feel any pressure. You are in control and can do as much or as little as you like.

When you look through the Language of Flowers Meanings on pages 141–142, does one of them speak to your heart more than the others? Consider doing one or more of these things:

- Make a bouquet for someone you've hurt when you didn't take accountability. If you wish, write out a flower message to that person—or not. As long as *you* know what each flower represents, you're sending a message.

- Next time you're at a florist shop or in a craft shop, pick up some real or artificial flowers that you can put in a vase at home to send a special message to yourself.

- Write a prayer based on a flower's meaning.

FOR EXAMPLE:

Lord, thank You for lavender, and thank You for serenity and calmness. Some days my life feels a little bit crazy and I long for more of Your peace. Help me find moments of calm in the midst of the busyness. Amen.

SESSION 10

WALKING THROUGH THE VALLEY

Courage

ART SUPPLIES FOR SESSION 10

- ☐ 1 sheet of mixed-media art paper
- ☐ 1 set of watercolor paints
- ☐ Large acrylic paintbrush
- ☐ Disposable cup or water container
- ☐ Paper towels or rag for cleanup
- ☐ Pencil

Stephanie Logan Segel

Watch a video from Martha and Stephanie about this week's session at tyndale.life/create_session10.

LOOKING AHEAD

In this session, we are going to explore the topic of courage. As we create a painting of mountain peaks and a valley, we'll share a personal fear and discuss times when we've responded with courage.

LOOKING INSIDE

> Courage doesn't always roar. Sometimes courage is the quiet voice at the end of the day saying, I will try again tomorrow. —MARY ANNE RADMACHER

Have you ever been afraid? Of course, you have—we all have! From childhood to the present, we all have fears. Maybe yours is a fear of the unknown, or you're afraid of the dark. Perhaps you're afraid of failure or afraid you're not enough. Whatever form your fears take, we'll begin today's session with a promise from the Bible that will encourage you:

> I am the LORD your God who takes hold of your right hand and says to you, Do not fear; I will help you. —ISAIAH 41:13

It is easy to let fear run away with our emotions. The challenges we face, our memories of past experiences, and an unknown future can cause us to lose our courage. Our God, though, is a God who never changes, and we can count on His promises to always be with us. God's Word says,

> It is the LORD who goes before you. He will be with you; he will not leave you or forsake you. —DEUTERONOMY 31:8, ESV

LET'S GO TO HIM IN PRAYER AND GIVE THANKS FOR THESE THINGS!

Lord God, I thank You for promising to stay with me and help, no matter what. With You, I don't need to be afraid. I ask You to come into my life and replace my fears with Your power and confidence and love, so that I can respond to challenges in thoughtful and productive ways. In Jesus' name, amen.

PRESENTATION OF FLOWERS

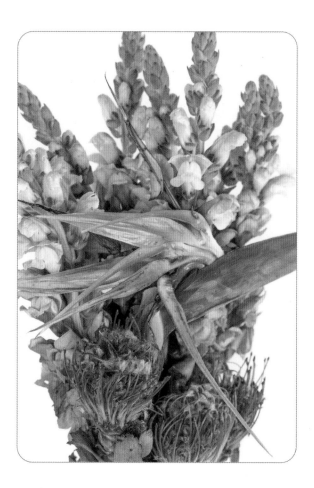

Now that you are familiar with the concept of the Victorian language of flowers, we'll go ahead and share one last little tidbit. Another name for this concept is *floriography*—which makes it sound even fancier. Let's see what today's flowers have to say.

We'll begin with PROTEA, which has more than 1,400 varieties of size, shape, and texture. Because of its diversity, the protea symbolizes change, transformation, and courage.

Our second flower, the SNAPDRAGON, is known for growing in rocky soil. It is tall and represents strength and grace under pressure.

Our message through today's flowers is this: Like the beautiful snapdragon, you, too, can grow and thrive—even in rocky soil. We hope you will have the courage in life to change and find joy, and that you will become an example of faithfulness and thoughtfulness for those you know and love. We pray that your hearts and minds will be filled with divine courage and strength when you need them most. Just as the flowers thrive and shine, we are grateful for your beauty and perseverance.

Love,
MARTHA & STEPH

Last, we have the BIRD OF PARADISE, whose bright colors carry connotations of joyfulness and freedom. It also represents the ideas of success, overcoming obstacles, faithfulness, and thoughtfulness.

SHARING OUR EXPERIENCES

Our fears are often deep-seated and may have formed a long time ago—some through random circumstances or as a result of mistakes, and others from a sense of self-preservation or safety. For example, a fear of heights may stem from an accident you had as a child. A fear of being rejected may be connected to a broken friendship from middle school. A fear of drowning could be rooted in the fact that you never learned to swim.

What is one of your fears, and where do you think it came from?

When we do something even when we're afraid, we're acting courageously. Courage can be shown in many ways. Look at the diagram below. In the center, you'll see the words *Courage is*. Take note of the labels in the four connected lines: "Saying No," "Saying Yes," "Saying I Love You," and "Saying I'm Sorry."

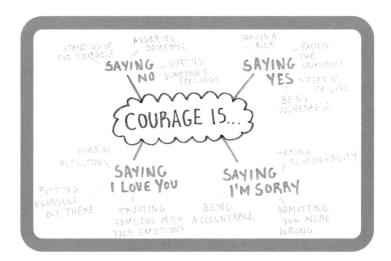

Why do you think saying those statements requires courage? As an example, a reason someone may be afraid to say "I love you" could be fear of rejection. Take a few minutes for members of the group to share their responses and add them to your page. Try to come up with three or four reasons someone might be afraid to say each phrase.

Today's session is about learning how to have courage. Did any of the answers surprise you? As you can see, sometimes being courageous looks different from what we might have imagined. Let's talk about that. Take your time and read each of these important definitions or distinctions.

- Bravery is the ability to confront pain, danger, or intimidation *without feeling fear.*

- Courage is *not* about being brave or doing something extreme or dangerous. It is confronting pain, danger, or intimidation *even though you feel fear.*

- No matter how difficult the circumstance, we can always find a tidbit of courage, even if we are not feeling very brave.

- It isn't always easy to deal with the situation in front of you, but simply choosing to face a situation head-on (instead of giving up or avoiding it) is an act of courage. It doesn't mean you're not afraid. It's a conscious choice.

- There are times, however, in which we do not hesitate to do what is needed, in spite of our fears, especially when it comes to those we love. This, too, is courage. When we are deeply invested or passionate about something, courage comes easier—but that doesn't make it any less courageous. For some reason, it can seem easier to find courage for other people than for ourselves.

GET READY

WARMING UP

Keeping in mind the characteristics of courage and bravery we just read, we are going to do a brief writing exercise. Using your pencil, write about a situation in your adult life when you felt afraid yet chose to face your fear.

Think about *how* you were able to face your fear. What did you do? Were there people who said or did something to help you? For example, "I'm scared of heights, but I told myself that if little kids could go on that roller coaster, so could I." You have five minutes to write about facing your fear beginning on this page and finishing on the next one.

How did you feel when you were thinking about the time you showed courage? As a group, discuss the feelings that came up.

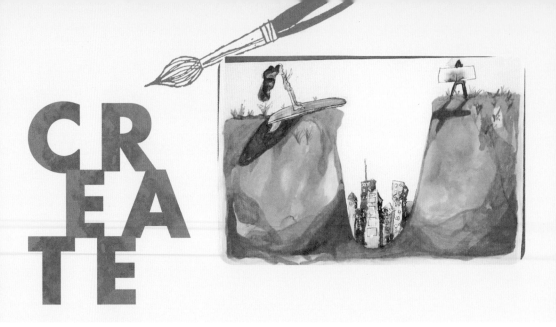

CREATE

To begin the painting, you will use the drawing below as a guide, making two peaks and one valley on your mixed-media paper with pencil. Be sure your paper is in landscape orientation, which means the long side is going left to right. Enlarge the peaks and valleys to mostly fill the page, leaving some space above the peaks.

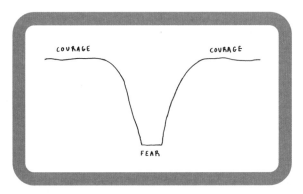

First, you are going to fill the valley with words or drawings that represent a time when you felt a fear that you were unable to overcome. This could be something that happened when you were a child, or it could be a more recent event. You may roughly sketch that scene with stick figures, or use words to describe it, but don't paint it quite yet. This drawing isn't meant to be perfect; instead, it's about the process of putting your feelings on the paper in whatever way you can.

Then, think of two different times in your life when you felt courageous. Quickly sketch a simple drawing of those moments on each of the two peaks.

Once you have all three memories identified, take another look at the Color Emotions Chart on page 145. Colors are linked to our emotions and say different things (much like the silent language of flowers). Here are a few examples to refresh your memory. Yellow signifies joy and happiness. Blue can represent peace, trust, or relaxation, as well as sadness. White represents purity and innocence, and orange expresses creativity and determination. Green symbolizes growth, harmony, and healing. Black can show power or elegance as well as mystery or death.

Use your memories to help you choose the colors you use. How did you feel at the time of the event? How do you feel now? How would you like to feel in the future?

As you apply your watercolors to the paper, remember to use a lot of water. Water will help your paint go further and will make the colors softer and more fluid. Have plenty of water on your brush before you place it into the desired paint color, and then apply it to the page. When you are finished with one color, swish your brush back and forth in the water several times to remove any remaining pigment before you start with another.

Now, go ahead and begin painting your valleys and hills. Your representations of your memories can be abstract or literal. Spend the next twenty minutes completing your painting.

VIEW AND APPLY

Sharing our experiences with one another helps us all to learn and brings us closer. As we look at the following questions, feel free to answer them or share your artwork with everyone.

1. Was it more difficult for you to come up with a fearful time or a courageous time? Why do you think that was true for you?

2. Imagine that you were able to build a bridge over the valley, bypassing the fear completely. If that were possible, would you want to do that?

3. Do you think that your fearful experience helped you learn to be more courageous?

So many times, the root cause of our mistakes and pitfalls in life is fear—fear that causes us to make poor choices or settle for less than God's best. However, the Word of God tells us we do not need to fear. The phrase "fear not" occurs more than three hundred times in the Bible. We share this not to make you feel bad for experiencing fear, but to show you how common fear is. The writers of the Bible understood that fear is part of the human condition.

They also knew that God's Word could help us overcome it. Psalm 23 is a great source of encouragement, particularly in this verse:

> Even when I walk through the darkest valley, I will not be afraid, for you are close beside me. Your rod and your staff protect and comfort me. —PSALM 23:4, NLT

And consider these words:

> Be strong and courageous! Do not be afraid and do not panic before them. For the LORD your God will personally go ahead of you. He will neither fail you nor abandon you. —DEUTERONOMY 31:6, NLT

We do not have to allow fear to defeat us. Remember, courage isn't being fearless. Instead, it is a decision to move forward even in the face of fear. To choose to take that next step. To decide to try again, one more time. To trust God's promise to walk with us. If we are willing to bring our fears to God and ask for His bravery, we can find the courage we need to overcome all our fears.

LET'S PRAY.

Lord God, thank You for being my Shepherd and remaining near, even when—especially when—I am afraid to take that next step or I am already walking down the wrong path. Give me the courage to believe Your Word and walk through life with the confidence that You are with me, protecting me and guiding me. In Jesus' name, amen.

REFLECT AND REMEMBER

Here's what past participants have said about their experiences. Read through their words, and then add your own brief reflections to help you remember what the session was all about.

COURAGE

- "When I look at my mountain painting, I remember how good it felt to choose courage."
- "I never knew I could paint, and it is so soothing to my mind. I love the way the session keeps me in a positive mood."
- "Painting and talking about fears make me feel like I have managed them and they no longer control me."

WHAT I SAY

REINFORCE

This completely optional exercise is designed to help you retain what you just learned. If it is fun for you to do so, you may complete this during the coming days, but do not feel any pressure. You are in control and can do as much or as little as you like.

Ready to face your fears? Remember, courage is not about being brave or doing something extreme or dangerous without fear; it is about confronting pain or danger *even though* you feel fear.

In a notebook or journal, write down a list of your fears. It may include public speaking, asking your boss for a raise, showing your true self to a friend, traveling to someplace new, or meeting someone new for lunch.

Look back over your list. Is there one fear you would like to conquer? It is natural to feel a measure of anxiety at trying something new, but pay attention to your instincts and don't push yourself to do something that feels dangerous or unwise.

Now pray and ask God to guide you. Write down the next step you can take to begin conquering that fear. Sign up for a speaking class, schedule a meeting with your boss to discuss opportunities within the company, start putting together a budget for your dream vacation, or text a friend an invitation to lunch.

As you begin to face the things you are afraid of, your confidence will grow, and you will find yourself choosing courage more often than you ever imagined.

EPILOGUE
AND THAT'S A WRAP!

You made it! You finished what you began—and we're so grateful you chose to spend this time with us. But more than that, we're giving thanks for all that we hope and pray you found in these pages and these projects. This study was never meant to be about creating beautiful art, and now we believe you'll understand why we said that. The art projects were a way for you to work around your defenses to see the truth of your emotions and feelings. They were carefully, prayerfully created to give you the opportunity to assess your inner landscape and turn over to God those things that are weighing you down or holding you back. They were intended to help you see the beauty and value that you have—that has been there all along.

Each participant has different stories and life experiences with varied personalities and a variety of stumbling blocks. We handle our emotions and stresses in numerous ways. We have independent goals and different types of support systems. What holds us together is that we all share faith in the same God, and we can say with confidence that God loves you right where you are. He adores you, flaws and all.

And yet, He also knows who you can become. Who you will be when you let yourself be transformed by His immense love and unfathomable grace. Who you are when you allow His transformative light to shine through you into the lives of everyone you touch. We hope you will allow yourself to absorb these truths and remain open to letting God create in you a new heart, one that is tender and responsive. One that is vulnerable and expresses empathy and compassion. One that is forgiven and forgives, and works to reconcile what is broken. One that is free from the shackles of shame, confident and yet humble. One that holds itself accountable and has the courage to face each new day.

One that creates, again and again, a new and better beginning. Thank you for sharing your heart with us.

We'd love to hear about your experience. Drop us a line at info@pfm.org or follow Prison Fellowship on social media.

ABOUT PRISON FELLOWSHIP

Thanks for walking with us on this creative journey. We wanted to tell you a little bit more about Prison Fellowship, the organization behind this program.

The ministry was founded in 1976 by Charles Colson, who served seven months in prison for a Watergate-related crime committed when he was an aide to President Richard Nixon. Prison Fellowship serves all those affected by crime and incarceration. We believe every person is made in the image of God and that no life is beyond His reach. We know that all people, regardless of circumstance, are loved by God and worthy of our attention. And when God is in the picture, there is always hope. Our goal is to see lives and communities restored in and out of prison—one transformed life at a time.

Our staff and volunteers run events and programs in correctional facilities across the country, sharing the gospel and spreading hope to those who are incarcerated. We serve the women and men who are behind bars and minister to families torn apart by incarceration.

Together, we strive to make prisons safer and more rehabilitative, advance criminal justice reforms, and help all those affected by crime to heal and flourish. We advocate not only for justice but also for restoration through proportional punishment, constructive corrections culture, and second chances.

Prison Fellowship Angel Tree helps churches support the families of prisoners year-round by delivering Christmas gifts on behalf of incarcerated parents, sending kids to summer camp, facilitating one-day sports camps, and more.

Years ago, founder Chuck Colson said, "Arts are an important way to understand God and his creation. In a post-Christian culture, those who blend artistic gifts with Christian faith can help lead us back to a biblical worldview. That is why the church should encourage them."

When we started the Create: New Beginnings program, we were simply wanting to offer women in prison a restorative way to process their emotions and understand their worth in God's eyes—but here is the truth: Every one of us can benefit from that, whether we've experienced great trauma or had relatively safe lives.

As you look back on your own discoveries and transformation through the art projects in this book, we hope you will remember those who have been affected by incarceration and feel a deeper connection to them.

Creator God, open the eyes and hearts of those reading these words. Help us to understand that Your limitless love is for each of us. That Your insights and wisdom will guide each of us, no matter where we come from or where we are going. Help us individually to search our hearts and know how to serve You—and how best to show others Your great love and plentiful grace. Amen.

Want to learn more about what we do—or ways that you can be involved? Visit prisonfellowship.org/womens-ministry/create-new-beginnings/ to learn more about the impact Create: New Beginnings is having for women in prison through its restorative art sessions.

CREATE:
NEW BEGINNINGS™
A Program of Prison Fellowship

FACILITATOR'S GUIDE

We're so glad you're here! But we don't want you to feel as though you're doing this all alone, so we're including this section for those of you who have chosen to (or been asked to) lead a group through this process.

Our goal with *Create: New Beginnings* is to provide a safe space in which everyone can be vulnerable and feel comfortable creating and sharing in the restorative art-based exercises. As the leader or facilitator of a group, you are integral to creating a safe space for the women participating. One of the main ways you will do this is by getting involved in the activities and sharing alongside the other volunteers and participants.

Let's start with the big picture. As you plan, be sure to allow approximately two hours for each session so that you have time as a group to read and discuss the topic, and still have plenty of time to create your art projects. Participants will need room to spread out their art materials and books, so it's best if you have plenty of space.

Speaking of the art—you may choose to have each participant bring her own materials, or your church or other organization may decide to provide them for all. Be sure to tell participants ahead of time what they are responsible for providing and give them plenty of advance warning so that they can be prepared for the first session.

In the years that we've offered this program, we've found some tried-and-true tips, which we'll share with you. But don't worry if you can't do it all. Our hope is that together we can create a safe, stress-free atmosphere—for participants, but also for you.

You will need a few things besides your own art supplies:

- Whiteboard and whiteboard eraser or large flip chart to write on
- Set of whiteboard/flip chart markers of various colors
- Pencil sharpener
- Timer (can be on your phone)
- Music (CD player or Bluetooth speakers with phone or computer)
- Flowers and vase (optional; read more under "Presentation of Flowers")

BEFORE PARTICIPANTS ARRIVE

- Place the vase of flowers for the day's session on a table or chair in the center of the room so that everyone can see it. (See the Presentation of Flowers section that follows on page 139.)

- Write the key quote for that day's lesson on a whiteboard or large pad of paper (leaving room for session activities).

- As you arrange the meeting space, think about whether you plan to discuss each topic in smaller groups. You may want to arrange participants' seating in a semicircle facing the front of the room or have several larger tables around which people can work facing each other. This makes splitting into groups natural and efficient.

- If you are providing materials, ensure you have plenty before participants arrive. It never hurts to have extra.

- Set up the music player to begin playing music before participants arrive. Soft music helps create a relaxing and creative atmosphere.

- Each session contains a link to an accompanying video with Martha and Steph. If desired, cue each video up before the participants arrive and watch it together at the beginning of the session. Even though some of the video content differs from what is in the book, you'll be able to "meet" the creators.

TIPS

- At the start of every session, state the topic/goal and then remind everyone that this is a safe space, and that what is shared should be kept confidential and not be repeated outside this room.

- Read through the content together. When you get to questions in the lessons, stop and discuss as a group (or divide into small groups if needed).

- Play soft music during times of creating to help people reflect and feel comfortable. If you or a volunteer subscribes to Spotify, we've created a *Create: New Beginnings* playlist that you can use if you wish. Find it here: https://open.spotify.com/playlist/3r8TE5oAJ3JzwkjlZWk4dn.

- When it's time to create, read the directions aloud, step by step, and ask for questions before the participants begin. Be sure to share how much time they have to complete

each step and set a timer. Remind participants of their time twice: at the five-minute mark and again at two minutes.

- IMPORTANT NOTE: Some sessions go very deep emotionally and may remind participants of painful experiences. There is a possibility that certain discussions could trigger emotional distress or memories. You want to be able to point the person in a direction where they can be comforted, so always know who you should notify if this happens (a pastor, counselor, or other volunteer). Always be encouraging and positive with your comments. If a participant shares something deeply personal and painful, follow up with positive words and express gratitude for her willingness to share. If a participant displays symptoms of despair, let your designated contact know as soon as possible.

PRESENTATION OF FLOWERS

Depending on your location and the time of year, you may or may not be able to obtain the specific flowers discussed in each session. We encourage people to bring real flowers; however, we know that some people may not want to (or be able to) buy them fresh every week, so we have included images in this workbook. If you are unable to bring in live flowers, or cannot find the specific flowers mentioned, you may use photographs or artificial flowers.

Consider inviting participants to be part of this by taking turns providing flowers. You, as the facilitator, would bring flowers the first week and explain how to do the flower message. At the end of the session, a designated participant takes them home in a vase, purchases the flowers for the next week, and presents the flower message. And so on. Please stress to the participants that if they are unable to get the fresh flowers, they should let you know before the session begins so that you can be prepared to refer to the photos in the book.

Once the flowers have been presented, display them in a vase for the participants to enjoy during that session.

The presentation of flowers can be skipped if time or availability is limited, but we think the meanings and insights they represent are valuable to the lesson as a whole, so we encourage you to try to make it work.

Refer to pages 141–142 for a list of flower meanings.

Tip: If you use artificial flowers, hold on to them after each session because they can also be used in the still-life artwork in session 9.

We're so glad you have chosen to be a part of this program with us.

LANGUAGE OF FLOWERS MEANINGS

As mentioned previously, in the Victorian era, a gift of flowers conveyed a specific but unspoken message, depending on the flowers given. This became known as the language of flowers. Following is a list of flowers with the feelings and messages associated with them. In some cases the color of the flower gives added meaning. We've included extra flowers not mentioned previously in this book that you can use to develop your own messages if desired. Or feel free to research meanings on your own!

ALSTROEMERIA: Devotion and mutual support between a family member or friends; overcoming the trials of everyday life; following your dreams and achieving your goals; good luck.

AMARYLLIS: Splendid beauty; worth beyond beauty; pride.

ASTER: Patience.

ASTILBE: I'll be waiting for you; patience; dedication for a loved one.

BELLS OF IRELAND: Good luck.

BIRD OF PARADISE: Joyfulness; freedom; success and overcoming obstacles; faithfulness; thoughtfulness.

CALLA LILY (PINK): Appreciation; admiration.

CARNATION: I'll never forget you; pride and beauty (as in womanly pride); a mother's love.

CHAMOMILE: Energy; strength in adversity; patience.

CHRYSANTHEMUM: Optimism; honesty; joy; rest; longevity.

CHRYSANTHEMUM (WHITE): Loyalty; honesty.

CONEFLOWER (PURPLE): Strength; health.

DAFFODIL: New beginnings; eternal life.

DAHLIA: Dignity; grace under pressure; drawing upon inner strength; making a positive life change.

DAISY: New beginnings.

DELPHINIUM: Lightheartedness.

EUCALYPTUS: Healing; connection; leadership; self-protection.

FREESIA: Innocence; trust; friendship; thoughtfulness.

GARDENIA: Joy; you are lovely.

GERBERA DAISY (PINK): Happiness; admiration and high esteem.

GLADIOLUS: Strength of character; generosity; integrity; faithfulness; never give up.

GOLDENROD: Careful encouragement.

HYACINTH (PURPLE): Forgiveness; strength.

HYDRANGEA: Heartfelt emotions; gratefulness for being understood.

IRIS: Faith; hope; wisdom; trust; encouragement.

LAVENDER: Loyalty; serenity; grace; calmness.

LILY: Refined beauty.

LILY (ORANGE): Confidence and pride.

LILY (WHITE): Purity.

LILY OF THE VALLEY: Humility; sweetness.

LISIANTHUS: Gratitude; everlasting bond.

ORCHID: Beauty; love; strength; maturity.

PEONY: Happy life; happy marriage; good health; prosperity.

PEONY (WHITE): Remorse.

PROTEA: Change; transformation; courage.

QUEEN ANNE'S LACE: Sanctuary.

ROSE (ORANGE): Admiration; excitement; I'm so proud of you.

ROSE (PALE PINK): Grace; gratitude; joy; gentleness.

ROSE (YELLOW): Friendship; joy; caring.

SNAPDRAGON: Strength; grace under pressure.

STATICE: Success; remembrance.

STOCK: Beauty everlasting; joyous, happy life.

SUNFLOWER: Adoration or love toward someone such as a family member or friend; positivity; strength.

TULIP (PINK): Happiness; confidence.

TULIP (PURPLE): Admiration for one's accomplishments; abundance; prosperity; royalty.

TULIP (WHITE): Forgiveness; perfect love.

TULIP (YELLOW): Happiness; cheerful thoughts; sunshine.

LIST OF EMOTIONS

As you work through the exercises in this book, you may struggle to think of certain emotions. Here is a list to help you get started, but please do not feel limited by these. Use your experiences and imagination to be as specific as you would like. Pick out those that express your feelings when you say, "I feel _____."

afraid	curious	greedy	misunderstood	sad
aggressive	depressed	grieved	nervous	satisfied
amused	desire	guilty	nostalgic	shamed
angry	desired	hatred	objectified	shy
annoyed	disgusted	helpless	offended	spiritual
anxious	dissatisfied	hopeless	optimistic	stress
apathetic	doubtful	humbled	outraged	submissive
awkward	embarrassed	humiliated	panicked	surprised
bitter	empathetic	insulted	peace	sympathetic
bored	empty	jealous	pessimistic	thankful
cheated	excited	joy	powerful	triumphant
compassionate	faithful	lonely	proud	troubled
confused	frustrated	longing	rejected	underestimated
content	generous	love	relief	weary

COLOR EMOTIONS CHART

RED | ENERGY, DANGER, PASSION, LOVE, ATTENTION, ANGER

BLUE | CALM, PEACEFUL, RELAXED, TRUST, SADNESS

YELLOW | JOY, HAPPINESS, INTELLIGENCE, ENERGY, FEAR

PINK | LOVE, TENDER, VULNERABLE, CALM, FEMININITY

PURPLE | WISDOM, ROYALTY, DIGNITY, CREATIVITY, SPIRITUALITY

GREEN | GROWTH, HARMONY, SAFETY, HEALING, JEALOUSY

ORANGE | WARMTH, JOY, CREATIVITY, DETERMINATION, SUCCESS, HUNGER

WHITE | INNOCENCE, PURITY, SENSE OF SPACE, FAITH

BLACK | POWER, ELEGANCE, FORMALITY, MYSTERY, DEATH

COLOR MIXING CHART

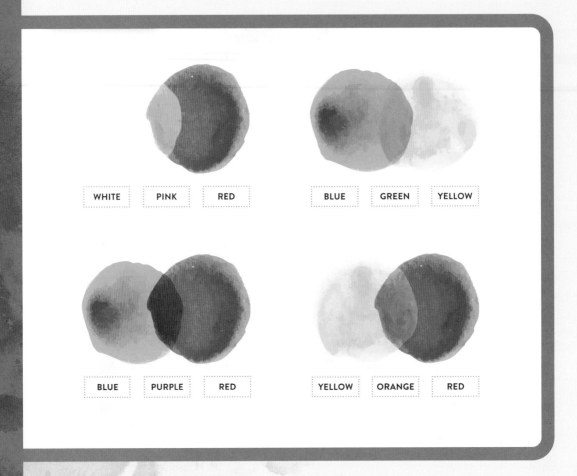

WHITE | PINK | RED

BLUE | GREEN | YELLOW

BLUE | PURPLE | RED

YELLOW | ORANGE | RED

BODY OUTLINE
TEMPLATE

ABOUT THE AUTHORS

MARTHA ACKERMAN is an artist and coauthor of Create: New Beginnings, Prison Fellowship's restorative art workshop. She is also the founder of Martha Ackerman Jewelry. She and her husband, James, have two adult children, Holden and Lily.

Martha's experience with art and design began with her work in the fashion industry in New York City. She also has a passion for women's issues, and over the years has volunteered with several organizations that address gender-based violence (particularly with adolescent girls), offering spiritual encouragement and growth, peace, and security. As a creative, Martha poured her passion for art and beauty and compassion for women's struggles into the curriculum for Create: New Beginnings, which is now in active use behind bars in twelve states and growing.

STEPHANIE LOGAN SEGEL is a Los Angeles–based painter, artist, and cocreator of Create: New Beginnings, Prison Fellowship's restorative art program. In 2017, she visited a prison for the very first time to create a mural inspired by the Human Connection Project, an original series sharing people's stories through art. That experience sparked the idea for Create: New Beginnings.

Steph's work reflects her passion for pursuing social justice, connecting people, understanding human emotions, and giving back to the community. She primarily works with oil paint and watercolors, specializing in portraiture. Her art has been featured in auctions and art shows in Los Angeles and New York and has found homes in private collections around the world. In 2022, she cofounded MoDa Studios in Los Angeles, a community workspace where local artists can excel in their God-given gifts. Steph studied psychology and studio art at New York University. Born in London, she currently resides in Los Angeles, California.

KELLY O'DELL STANLEY is a graphic designer who writes—or should we say a writer who also designs? Let's just say she loves to be in any space where faith, art, and writing collide. During thirty-plus years in advertising and marketing, Kelly has created award-winning work for a variety of brands across the United States—and beyond. She and her husband, Tim, have three grown children, and Kelly is proud of her role as "Minah" to three adorable, brilliant grandchildren.

NOTES